# Designing
# and
# Making Mosaics

Virginia Gayheart Timmons is Education
Specialist for Instruction and Staff
Development for the Baltimore City Public
Schools. She is on the advisory board of
*School Arts* magazine where her column,
"The Clipboard," appears monthly.

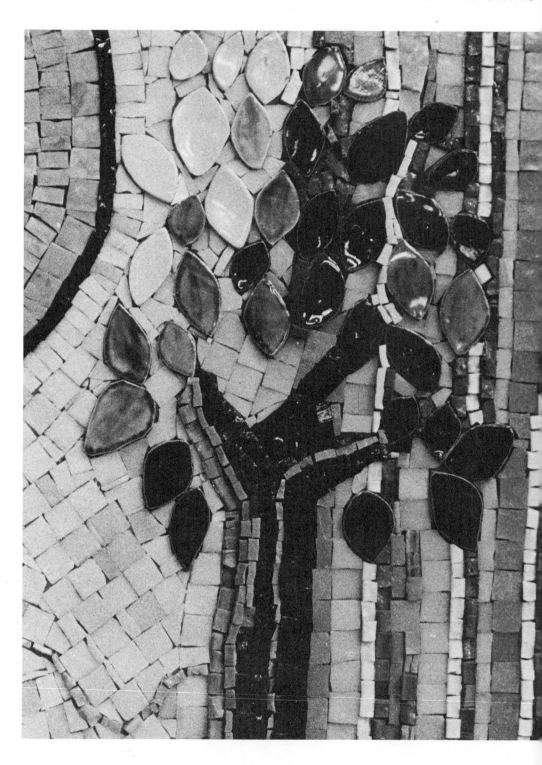

# Designing
# and
# Making Mosaics

VIRGINIA GAYHEART TIMMONS

A SPECTRUM BOOK

PRENTICE-HALL, INC. Englewood Cliffs, New Jersey 07632

97354

*Library of Congress Cataloging in Publication Data*

Timmons, Virginia Gayheart.
    Designing and making mosaics.

    (The Creative handcrafts series)    (A Spectrum Book)
    1. Mosaics—Technique.    I. Title.
NA3750.T5   1977        751.4'8       76-56194
ISBN 0-13-201954-X

Frontispiece: (Detail) *Mosaic panel*    Reinhold P. Marxhausen.
Hand-formed ceramic pieces, Venetian glass tile, smalti.

Prentice-Hall International, Inc., *London*
Prentice-Hall of Australia Pty. Limited, *Sydney*
Prentice-Hall of Canada, Ltd., *Toronto*
Prentice-Hall of India Private Limited, *New Delhi*
Prentice-Hall of Japan, Inc., *Tokyo*
Prentice-Hall of Southeast Asia Pte. Ltd., *Singapore*
Whitehall Books Limited, *Wellington, New Zealand*

# Contents

# Preface

My aims in preparing this manuscript are quite personal and easily defined: the desire to share my personal enthusiasm for mosaics and the hope of encouraging people to include mosaics in their plans for art activities.

Mosaics are especially appropriate in a program of art education: the student is constantly involved in making choices related to materials, colors, textures, shapes, values and how to use them in his own creative expression. As in other art activities, the reader's interest in mosaics grows by *doing*, by becoming acquainted with mosaic materials and learning how they can be used in countless, fascinating ways. The tactile qualities of mosaic materials are strongly inviting, almost compelling the hand to touch, to manipulate. Little motivation is needed once the reader has been provided materials and some basic guidance in their uses.

Traditional mosaic materials and tools are illustrated and traditional techniques are discussed since these have provided our masterpieces of mosaic art. The emphases of this book, however, are the varied materials of *contemporary* mosaics and the simple, basic

techniques appropriate for use in the home hobby room or the general art classroom. Experimental activities involving the use of newer materials are described to encourage an open-ended, exploratory approach appealing to beginners in this medium.

Examples of professional work shown were selected to illustrate contemporary uses of mosaic art, the wide range of modern materials and techniques, and the design approaches or styles represented in the work of outstanding mosaicists. Student work was drawn from different grade levels and illustrates how common materials can be used creatively in the classroom. A brief survey of selected historical examples is provided as background or point of departure for those who enjoy knowing something of the history of the art they practice.

The importance of mosaic art as a medium for "serious" art expression cannot be questioned; mosaic masterpieces that have survived millenniums attest to this. For the beginners the most effective recommendation for making mosaics can be stated quite simply—it is just plain good fun! When one has known the pleasure of creating a mosaic—whatever the material used—it becomes all but impossible to ignore a glittering fragment of glass, the tiniest pebble or the lowliest piece of "discarded" material. They find their way into coat pockets and handbags, to await the time when they can be incorporated in a larger, more unified whole. The artist's desire to create unity from diverse elements, to create order from chaos, is reflected in all truly creative art. The artist or student seeking the most responsive medium to this end need look no further than mosaics.

# Acknowledgments

In preparing materials for this manuscript I have sought the assistance and advice of many artists and teachers who, like myself, have found a unique satisfaction in designing mosacis and in encouraging mosaic art in the classroom. Their responses, without exception, have been warm and generous in terms of encouragement and in the illustrative materials they provided for my use. I am grateful to them, not only for the very real help they provided, but for the new friendships developed. Their contributions are noted in captions since a listing here would be quite extensive. My sincere thanks to all of them.

Appreciation is extended to the many museums, business organizations, and manufacturers who were most cooperative in supplying information and illustrative materials requested of them.

Special thanks go to Claude Tittsworth—friend, good neighbor, and patient photographer—for all photography work not otherwise identified. His contribution is a major one.

Appreciation and gratitude are extended to George F. Horn,

**xiv**

*Acknowledgments*

who read the manuscript and provided helpful criticism and suggestions, and to William B. Jennison, for his continued interest and encouragement during the preparation of this manuscript.

# Designing
# and
# Making Mosaics

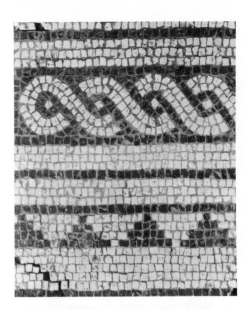

*Roman Mosaic*   2nd century A.D. Part of a mosaic pavement. Detail: front border. The Metropolitan Museum of Art. Anonymous Gift, 1945.

# 1 Mosaics Then and Now

The contemporary designer of mosaics practices an art that has its origins in the dim millenniums preceding the birth of Christ. From these ancient times to the twentieth century people have used mosaics to adorn their tombs, temples, houses, pavements, churches, and cities. The designs and images produced by arranging bits and pieces of clay, stone, marble, and glass have provided a vivid and lasting record of many and varied cultures.

As early as 5000 B.C., the Sumerians of Asia Minor decorated their buildings with cones of fired clay. The cones, colored white, red, or black at their bases, were pushed into a mortar of mud and chopped straw which was the commonly used Mesopotamian building material. From the Sumerian tombs at Ur came the Harp of Queen Shubad (ca. 2850-2450 B.C.) inlaid with gold leaf, lapis lazuli, and shell. Inlays of this type are among the earliest mosaic art known.

From the first millennium B.C. through the sixteenth century, the Pre-Columbian cultures of ancient Mexico and Central America practiced mosaic arts. The surfaces of sculptures, masks, ornaments,

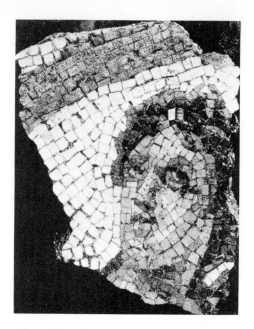

**Figure 1.2** *Fragment Depicting A Head*
Syrian Mosaic. 1st-2nd century A.D. 8'' x 6''.
The Baltimore Museum of Art. Antioch Project
Fund.

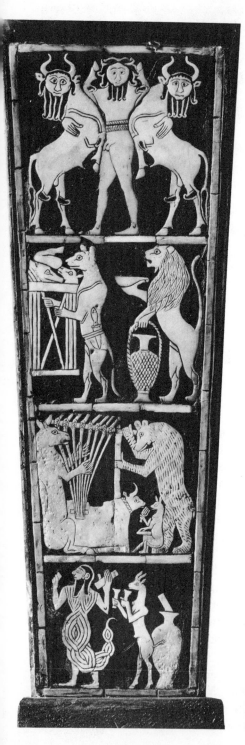

**Figure 1.1** *Mosaic Plaque from Harp of
Queen Shubad* Ur. ca 2850-2450 B.C.
9'' h. Shell inlay. Inlays of this type were
among the earliest forms of mosaic art.
In the figures at the top of the plaque,
the god Gilgamesh seizes and subdues
two human-headed bulls which represent
the wild tribes conquered by the
Sumerians. The animals in the lower
panels, engaging in human activities,
suggest the bestiaries, or beast stories of
the Middle Ages, which are known to
have come from the East.

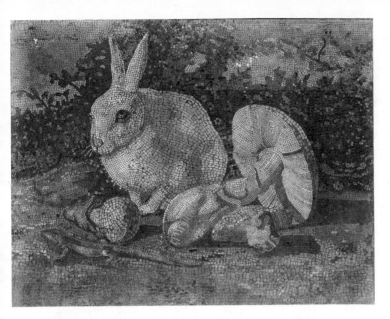

**Figure 1.3** *Rabbit with Mushrooms and Lizard* Mosaic of glass
cubes. Roman. 1st century B.C. The Metropolitan Museum of Art,
Gift of J. Pierpont Morgan, 1917. Note the unusual variation in sizes
of glass cubes and how sizes are utilized in defining contours and
forms. The handling of the tiles in the upper right section appears
surprisingly free while the head of the rabbit is finely detailed.

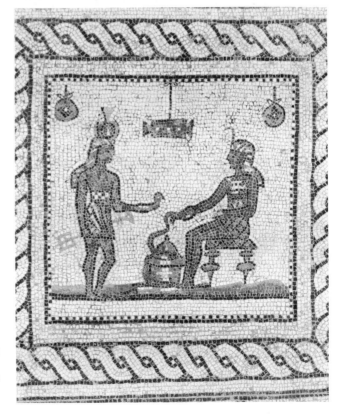

**Figure 1.4** *Roman Mosaic* 2nd
century A.D. Part of a mosaic
pavement. Detail: Priest of Isis. The
Metropolitan Museum of Art,
Anonymous Gift, 1945.

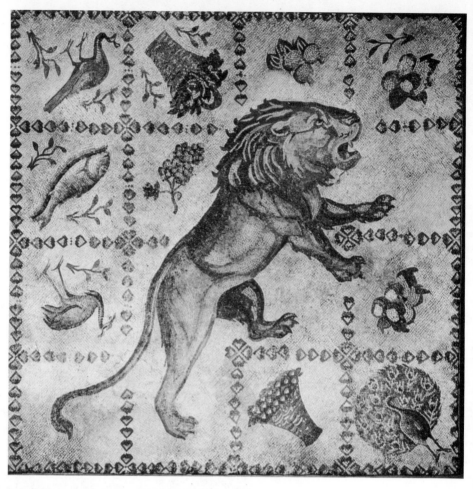

**Figure 1.5** *Mosaic Floor of the Striding Lion* Antioch (Byzantine). Probably 5th century A.D. 14'8" x 28". The Baltimore Museum of Art. Antioch Project. Later floor designs incorporated motifs from nature, interpreted in increasingly complex mosaic patterns.

and jewelry were enriched with fragments of turquoise, jade, obsidian, silver, and gold, reflecting fine craftsmanship and a remarkable sophistication.

The Egyptians, in an era paralleling the early Sumerian culture, decorated their temple walls and columns with inlays of glass and semi-precious stones. The Greeks of the the century B.C. found that a mosaic of small stones improved the appearance and durability of a mud or stucco floor.

In the centuries that followed, the Greeks and Romans developed large-scale uses for mosaics covering the walls and floors of their villas with tiny squares of black, white, red, and green marble. Outside, mosaics covered fountains, pavements, and city squares.

What has been referred to as the Golden Age of Mosaic spanned the Early Christian period in Southern Italy, paralleling the Byzantine period. Early Christians had designed mosaics on the walls of catacombs but with the conversion of the Emperor Constantine, mosaic art burst out of the catacombs to adorn the walls of great churches and cathedrals. The spirituality of Christianity uplifted mosaic art; worldly themes were replaced by religious themes which taught the sermons of the Bible to the illiterate.

Artists were sent out from Constantinople to decorate vast church interiors with gemlike glittering mosaics, glittering because now glass

**Figure 1.6** (Detail) *Empress Theodora and Retinue* Copy of original mosaic in the Church of San Vitale, Ravenna, Byzantine, 6th century. The Metropolitan Museum of Art, Fletcher Fund, 1925. Theodora, the wife of the Emperor Justinian, is shown entering the church from the narthex, bearing a chalice containing wine. The offertory theme is repeated by the figures of the three wise men, embroidered on the hem of her robe. The figures are portrayed frontally, in the manner of royal persons accustomed to receiving homage of their subjects. The royal image is further enhanced by the halo, a symbol of semi-divine status.

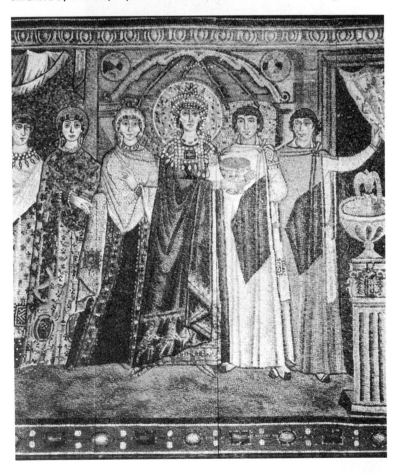

was available in gem tones and much of it was fused with thin sheets of gold. Unlike fresco painting, mosaics were especially well-adapted for use in the dimly lit interiors, catching every ray of light and reflecting it. Mosaic artists exploited this characteristic of mosaics, tilting each tessera and setting it directly into mortar to produce an uneven surface of vibrant, broken color. The result was a radiance that emanated from within the church, adding to the spiritual atmosphere.

Through the fourth and sixth centuries, mosaic art reached its height: Venice, Ravenna, Rome, and Constantinople became centers of great mosaic art. This period saw the building of San Vitale and the Tomb of Galla Placida at Ravenna and the Hagia Sophia in Constantinople.

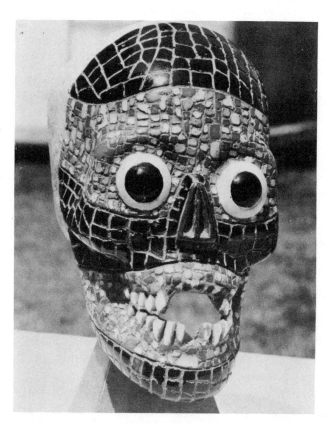

**Figure 1.7** *Calavera Mask* Mexico. Post-Classic period. A human skull forms the base of the mask, decorated with two bands of turquoise fragments and three bands of obsidian. The eye sockets are covered with inlaid shell and obsidian. Masks were important in the cultures of pre-Hispanic Mexico. Photo courtesy Mexican National Tourist Council.

Beginning in the tenth century, mosaic art was executed in the hieratic manner, a rigid, formalized style designed to inspire reverence and meditation. Strictly enforced rules governed even how artists were to depict the human form. With the fourteenth century and the dawning of the Italian Renaissance, mosaic art began a

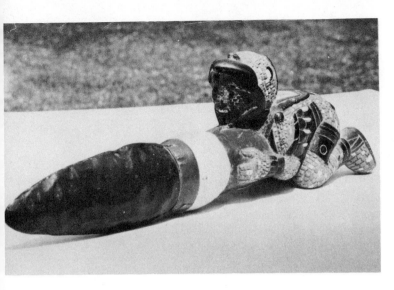

**Figure 1.8** *Sacrificial Knife* Mexican. Aztec. Considered a sacred object in the ritual of human sacrifice, this knife was richly mosaicked with turquoise and semi-precious stones. The handle represents a kneeling Eagle warrior.

decline that was to last for centuries. Glassmakers were now producing glass in colors that approximated paint colors; the Vatican developed a factory that provided 300,000 colors and tones. Mosaic artists, aware of the importance accorded the master painters of the Renaissance, attempted to produce mosaics so perfectly blended in color that they were often mistaken for paintings. Many mosaic artists simply reproduced the works of the leading painters of the time.

It was during this period that the indirect method was first used and developed. A cartoon was enlarged from the artist's sketch and meticulously copied on paper by students or assistants. With the colors indicated in paint, the paper was sized and carefully marked with top and bottom indications. The paper was then numbered, cut into manageable sizes, and distributed to assistants who proceeded to glue the tesserae as indicated by their colored paper. Each artisan worked independently, having no knowledge of the work as a whole.

The completed papers were then transferred to the installation site where another team of men, skilled in the application of these paper sections to the wall, began their work. The paper sections were pressed into the mortar-covered wall and gently tapped to insure a strong bond. When the mortar had hardened sufficiently, the paper was soaked with water and peeled away to reveal a flat, perfectly even mosaic surface.

The sensitivity and directness of the old, direct method were lost: the unique, uneven surfaces created by setting each tile individually were not possible in this indirect method.

Changing economic conditions eventually influenced the use of
7 mosaic decorations. Mosaic materials were expensive and the designs

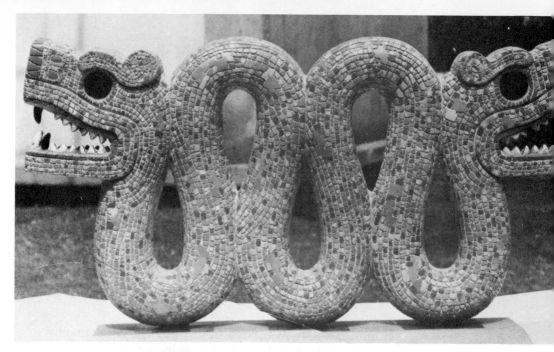

**Figure 1.9** *Two-headed Serpent* Mexican. Aztec. Late 15th-16th century. 16½" 1. Wood overlaid with turquoise. Teeth are mother-of-pearl, the eyes obsidian. An ornamental piece, believed to be a gift from Montezuma II to the conquering Spaniards. Photo courtesy of Mexican National Tourist Council.

expensive to install. Fresco came to supplant mosaic as the favored companion of architecture.

Although mosaic art continued, particularly in Florence where it was fostered by the Medici family, the major form it took was quite different. The ground and polished surfaces of natural stones were cut and closely set so as to simulate such naturalistic images as feathers of birds, scales of fish, landscapes, and cloud formations. The technique is known as *comesso* or "Florentine mosaic." It is often overworked and tasteless in its extravagant simulations.

Although comesso work enjoyed wide popularity, even into the eighteenth century, it never approached the awe-inspiring grandeur of the Early Christian period when mosaic artists made no attempts to create effects better left to the painter.

## MODERN MOSAICS

The renewed interest in mosaics that was evident in the mid-nineteenth century was expressed largely in the field of mural 8 decoration. The Venetian influence was still strongly felt and Italian

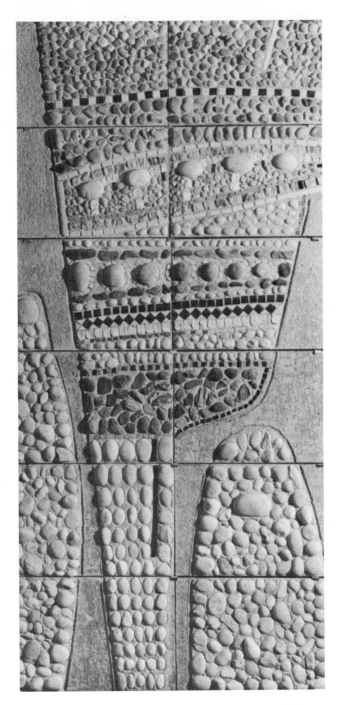

**Figure 1.10** *Garden Wall* 6′ x 3′ Aleksandra Kasuba. Pebble
mosaic. Note the variety of textures achieved by the careful
organization of pebbles of varying sizes. Small ceramic tiles are used
to create contrasting bands of dark tones. Photo courtesy American
Crafts Council and the artist.

artists were imported to execute murals or, in many instances designs were assembled in Italian ateliers, then shipped to oversea sites where they were installed by skilled tilesetters. The esthetic quality of these mural designs was generally poor as artists continued to disregard the inherent characteristics of mosaic materials, using them to create the effects of paint. Subject matter was largely illustrative; the use of mosaic materials in pure design remained relatively unexplored.

**Figure 1.11**   *Central Library, University of Mexico*   Juan O'Gorman, architect and artist. Mosaic murals, composed of stones from many states in Mexico, cover all four walls of the building, depicting a different period of Mexico's culture for each wall. The part of the mural shown here represents the Spanish Colonial period. The mosaics, designed in the indirect method, were constructed in concrete slabs one meter square and attached, with anchor hooks, to a steel trellis fixed to the walls. Joints between the 4,000 slabs were filled with additional concrete after they had been hooked into place. The building and murals represent the most monumental integration of mosaics and architecture in the Western hemisphere. Photo courtesy Mexican National Tourist Council.

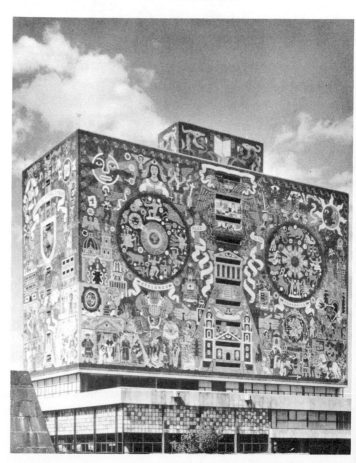

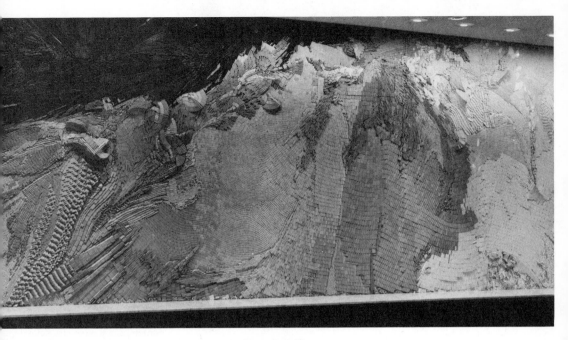

**Figure 1.12** *Solar Resurgence* Glen Michaels. Chase-Park Plaza Hotel, St. Louis, Mo. 32′ x 10′, in 8 panels. In a design composed of 20 different materials, including building tiles, slate, shale, reglets (wooden printer's slugs used to separate blocks of type), and rounded ceramic tiles, Michaels portrays man's conquest of space. Viewed from left to right, the mural depicts an emergence from darkness into light. The darkened area in the upper left-hand corner is composed of the reglets, darkened by ink through usage. Seams between the panels are joined with bits of broken hotel crockery. Photo courtesy of Chase-Park Plaza Hotel.

This renewed interest and activity in mosaics was short-lived: World War II closed the traditional European sources of mosaic materials and severely affected the manufacture of mosaic materials in America.

Following the end of World War II, mosaic artists joined other twentieth-century artists in breaking with tradition. No longer bound by traditional concepts and definitions, mosaic art was infused with a creative excitement by artists who envisioned mosaics as a medium for strong artistic expression. Mosaic art, long the handmaiden of architecture, now became an integral part of it, a functional part of building. The function of mosaic art was expanded to include the enrichment and improvement of many surfaces both utilitarian and decorative. Mosaic art, traditionally limited to permanent, fixed installation, was now applied to movable objects such as sculpture and decorative accessories, and to elements of interior design, such as room dividers and portable screens.

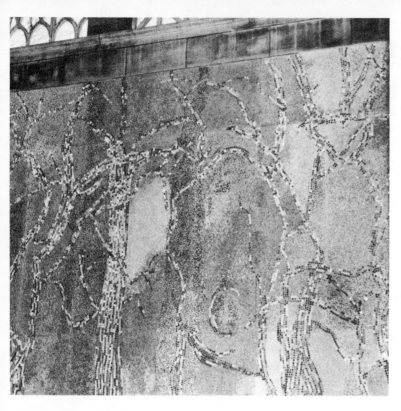

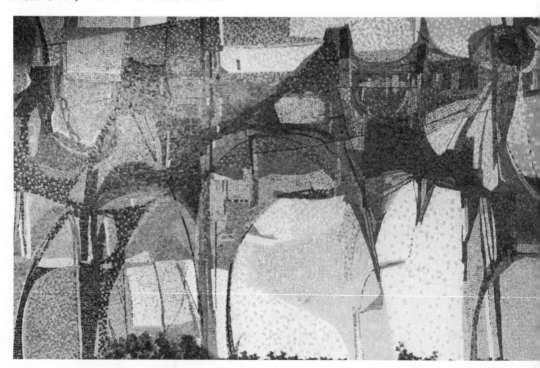

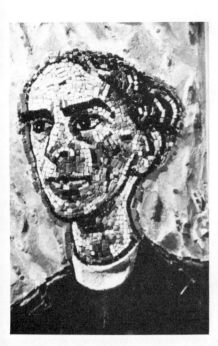

**Figure 1.15** *Father D'Arcy* Elsa Schmid. A mosaic portrait. Photo courtesy the artist.

**Figure 1.16** Mosaicist Reinhold P. Marxhausen, of Seward, Neb., at work on *Bethlehem*, a mosaic panel for Bethlehem Lutheran Church, Dundee, Ill. The panel is 12' x 8' and composed of wood and glass. Artist Marxhausen, a leading designer of mosaic art, makes extensive use of glass and wood in designs that often incorporate Biblical quotations. The letters are glass, closely outlined with pieces of wood.

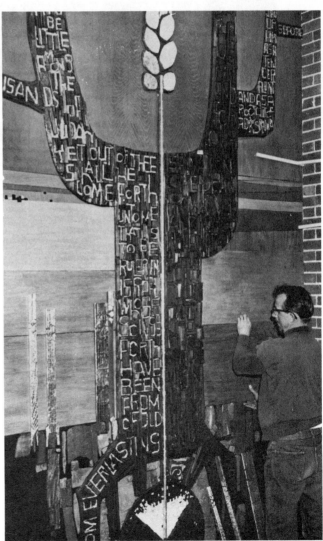

13

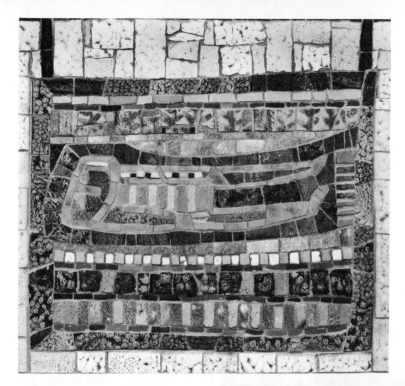

**Figure 1.17** (Above) *A Dream*
Aleksandra Kasuba. 13" x 14". 1960.
Ceramic mosaic. Photo courtesy
American Crafts Council.

**Figure 1.18** *Three-Dimensional
Screen* Lytton Savings and Loan
Assoc., Palo Alto, Calif. Roger
Darricarrere. Faceted stained glass dalles
in concrete.

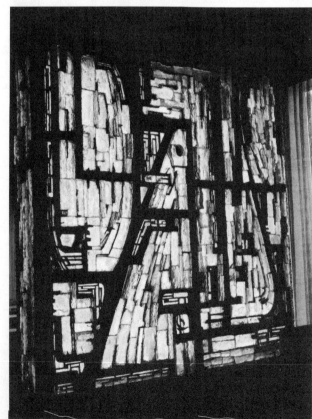

14

The development of new mosaic materials and, particularly, new adhesive materials has greatly influenced the expanding function of mosaic art. Epoxies have eliminated the need for the heavy mortars and grouts required to support in the old, traditional techniques. Improved building materials, particularly preformed panels, provide many effective "shortcuts" in the installation of large-scale mosaics.

**Figure 1.19** *Thanksgiving* Narthex niche, St. John's Lutheran Church, Seward, Neb. Reinhold P. Marxhausen. A spiritual theme expressed symbolically through found materials. The church membership is represented at the bottom of the panel by nameplates; "these things," by discards from the city dump; God, by the circle at the top of the panel. Artist Marxhausen, an outstanding contemporary mosaicist and teacher, portrays religious and spiritual themes in materials related to contemporary life.

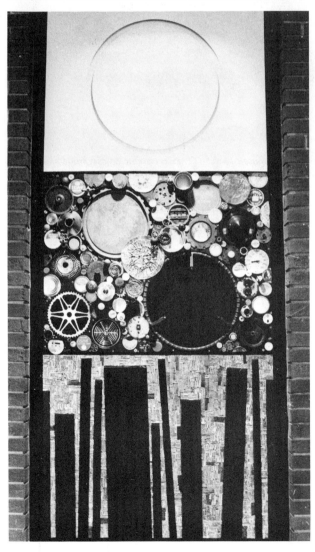

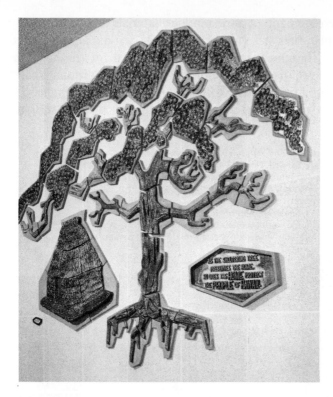

**Figure 1.20** *Mosaic Mural* Glazed ceramic on cast stone background depicting a corporate symbol. Royal Poinciana Tree is sculptured glazed clay tile of 40 individual pieces. Glazes are dark brown tones with vibrant red blossoms. Designed by Gerald Allison, AIA, for Home Ins. Co., and produced by Ceramics Hawaii. Photo courtesy Wimberly, Whisenand, Allison and Tong, Architects, Ltd.

**Figure 1.21** *Wood and Glass Sculpture* Roger Darricarrere. 14' x 3' x 8'' deep. Private collection, Lytton Savings and Loan Association, Los Angeles. A mosaic of faceted stained glass, manufactured by the artist himself, is combined in sculptured laminated wood. Photo courtesy the artist.

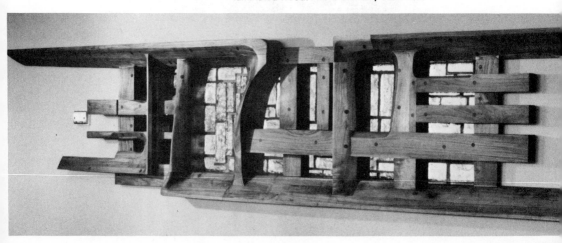

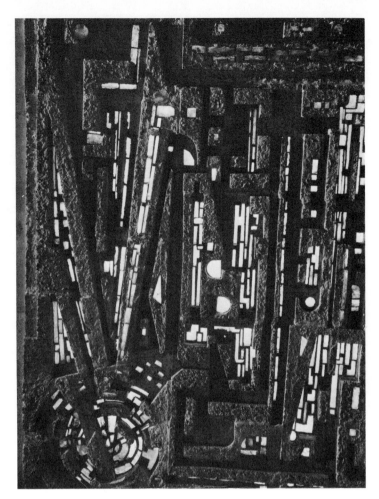

**Figure 1.22**   *Sculptural Glass Mosaic Wall*   Roger Darricarrere
8′ x 12′. Lytton Savings and Loan Association of Northern Calif.
Deep relief, 6½″. Glass to 1½″ thick, set in concrete.

Mosaic art is no longer confined to specific materials combined in rigidly prescribed methods: the mosaic artist today seeks and uses a wide variety of materials including the discards of everyday living: broken ceramicware, wood, scrap metal, watch parts, nuts and bolts—almost anything may be used. More concerned with expressive quality than with labels, the contemporary designer of mosaics is undisturbed if his work is called collage, construction, or assemblage. Of more importance to the artist is the expanded concept of mosaics which opens up new approaches to the problems of design, whether they be related to personal expression, interior design, architecture, **17**   or decoration "to please the eye."

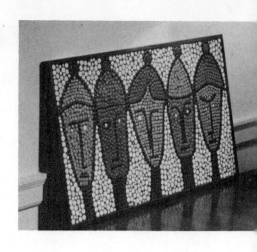

# 2 Designing for Mosaics

## AN APPROACH

A mosaic is not a painting; a mosaic is not a "painting in stones." Mosaics possess their own distinctive characteristics which should be understood before mosaic designs are planned—otherwise, results are apt to be poor imitations of paintings, totally unsuited to mosaic materials.

Mosaic materials are such fun to touch and to handle that your interest and enthusiasm for making a mosaic will be almost immediate. Brilliantly colored tiles of ceramic and glass; smooth, earth-toned pebbles; chunky bits of subtly colored marble—all have their fascination as they are held in the hand or moved about on a surface. This getting to know the material is vitally important in planning mosaic designs; the beginner soon senses that these materials do not lend themselves to hairline applications nor to finely detailed delicate designs as do pen and ink or paint.

Each type of material has its own unique texture, its own surface quality to lend to the overall design. As you instinctively begin

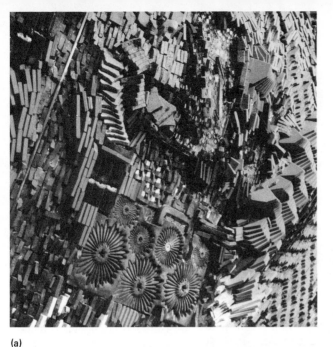

(a)

**Figure 2.1** (Details) *Mosaic Panel* Glen Michaels. Reception lobby, Bulova Watch Co., N.Y. Photo courtesy Bulova. 17' x 8'. Variety of tiles, stone, chips, glass, lead strips and assorted watch parts and other products of the Bulova Co. Approximately 47,700 pieces. Six basic themes, each reflecting one facet of Bulova's personality, are executed symbolically. In (a), the *International* theme, the Far East is represented by a Japanese chrysanthemum created in terra cotta together with Japanese women's hair combs. In (b), the United States is symbolically portrayed by a cloverleaf highway exchange, distinctively inlaid with lead strips and tiles.

(b)

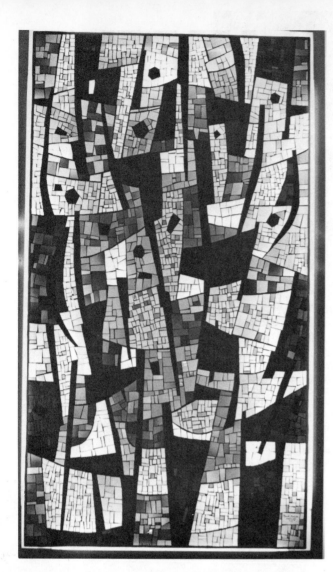

Figure 2.2 (Left) *Spring* Mariette Bevington. One of a series of four panels depicting the four seasons, Park Towne Place apartments, Philadelphia. Stained glass laminated to plate glass, 4' x 7'. Framed in brushed steel with lighting concealed in the frame. Note how the repetition of shapes creates an upward, lilting rhythm suggesting spring. Photo courtesy the artist.

Figure 2.3 *Appalachian Spring* by the author. Marble, pebbles, slate, and chunks of stained glass set in acrylic modeling paste, on ½'' plywood. The design was inspired by an aerial view of an Appalachian landscape, partially snow-covered, in early spring. Colors are gray, blue-green, light earth colors and white. 34'' x 18''.

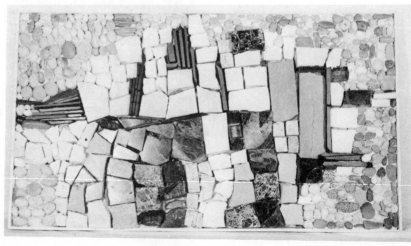

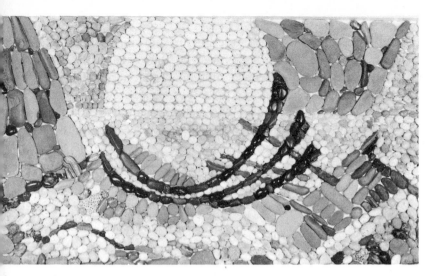

ure 2.4 *Wreck in the Cove* by the author. Assorted pebbles with white glue and acrylic modeling paste on plywood. Derived ᵐ an on-the-scene sketch, the final design merely suggests a rocky ᵉʳ, a ship's timbers, and the sea.

**Figure 2.5** *Summertime* Artist Chris Lemon interpreted the symbols of summer in a gay, whimsical glass mosaic which includes glass tile, beads, buttons, and a metal bracelet. Note how naturalistic forms have been reduced to simple, two-dimensional shapes. Materials are mounted with transparent cement on white-painted plywood, 17″ x 28″.

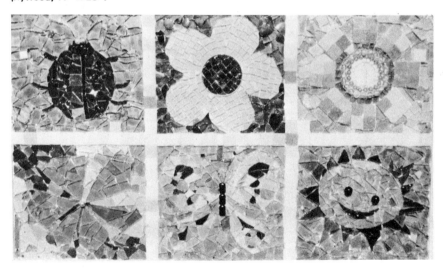

21

to arrange the materials into a design on work surfaces, your attention should be drawn to these tactile qualities since texture becomes extremely important in mosaic design. Try to shift the materials, noting changes that take place in light reflection and directional movement as tiles or stones are shifted or arranged in different ways. To explore different arrangements, experiment by embedding cut and uncut tiles in a slab of plasticene rolled one-quarter of an inch thick.

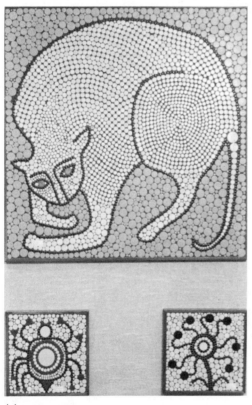

**Figure 2.6**   *Wall Panels*   Porcelain tiles. Marshall Studios, Veedersburg, Indiana. In (a), designs are stylized, and reduced to decorative elements that visually fill the total space available. Note the variety of texture and movement achieved by the way tiles are set on the body of the animal. These examples illustrate how a single shape of tile and limited colors can be used effectively. In (b), the design is created from the repetition of a basic shape, the head; interest is added by varying the treatment of each.

(a)

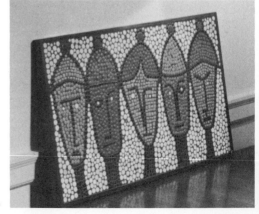

(b)

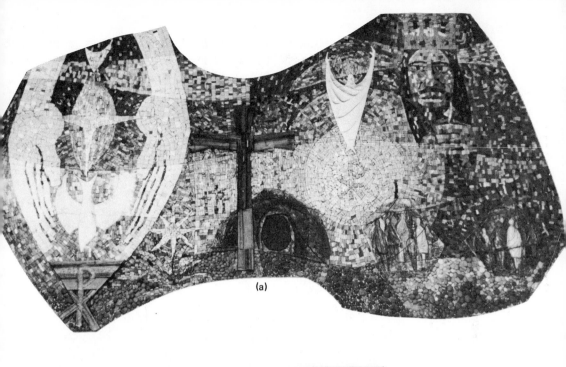

(a)

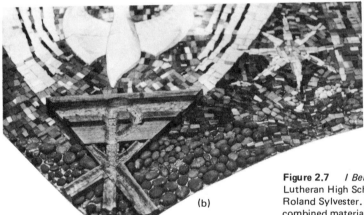

(b)

**Figure 2.7**  *I Believe*  Mosaic mural. 4' x 8'.
Lutheran High School. Gerald Brommer and
Roland Sylvester. Religious symbols interpreted in
combined materials including smalti and Venetian
glass tile, walnut, beach pebbles, ceramic tile, and
glazed and stained terra cotta. Photos courtesy
Gerald Brommer. (b) Detail.

Through the use of photographs, filmstrips, films, and other
illustrative materials you should become familiar with outstanding
works in mosaics from the past and from the studios of contempo-
rary artists. By carefully studying the work of individual artists, you
will become familiar with a variety of mosaic styles, techniques, and
materials. Consider the forms and functions of mosaic art and
compare them with other art forms to understand how mosaic art
**23**  has developed and changed through the centuries.

**Figure 2.8** (Top) *Shore Family* by the author. Pebbles and beach stones, set with white resin glue on plywood. The dark pebbles, from a garden supply shop, are polished for richer color and contrast. Although based on naturalistic forms of birds, the design is simplified and "flattened" for interpretation in mosaic materials.

**Figure 2.9** (Detail) *Mural* Temple Emanuel, Beverly Hills, Calif. Joseph L. Young. A careful study of the work of outstanding mosaicists reveals the importance of skillful cutting and placing of tile. In this design, each tile has a precise place and function; there are no random cuts. Note the variety of rhythms created on the table surface and how they relate to the rhythms of the total design. Artist Young uses felt marking pens and square-shaped pastels in planning the setting, size and color of each tessera in a design. Photo courtesy American Crafts Council.

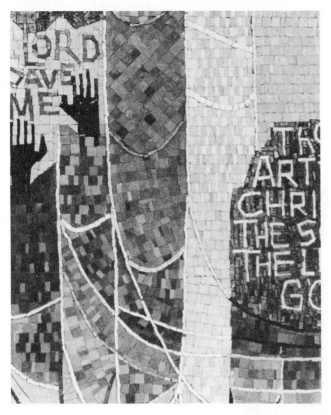

**Figure 2.10** (Above; detail) *Mosaic Panel* Venetian glass tile and smalti. Reinhold P. Marxhausen. Photo courtesy the artist.

**Figure 2.11** *Christ* Ceramic mosaic. Victor Casados. Collection Rev. Father Donald P. Rusch, Spearman, Texas. Symbols integrated in the total design.

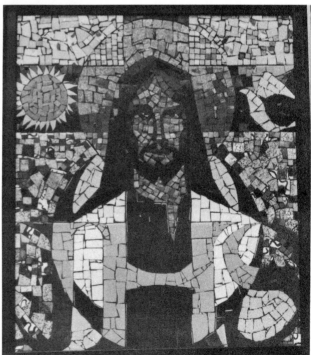

**Figure 2.12**    Plasticene slabs make ideal bases for experiments in
cutting and setting tiles. Beginners should practice basic cuts such as
cutting tiles in halves, in quarters, and making diagonal cuts to form
triangular shapes. Tiles may then be pushed into soft plasticene in a
variety of arrangements and patterns. Experiments such as these
help beginners to understand how tile "behaves" and how it can be
used in designing mosaics.

## DESIGN SOURCES

Where may we look for design sources and ideas? Quite simply,
everywhere; as in other design problems, the how is more important
than the what; how subject matter is treated is more important than
what the subject matter is. For example, the sun, the fish, the star,
the cross—all have been used as symbols throughout the history of
art. As treated by many artists, they appear trite and stereotyped; in
the hands of the creative artist they are visually exciting, interpreting
old meanings in creative applications. In developing ideas for mosaic
design, the beginner should avoid imitating the natural and should,
instead, regard the symbol, motif, or figure as simply a point of
departure for the final design. He can then look about him, with a
new way of seeing, for ideas, for starting points for design.

*Materials*, themselves, may inspire or suggest designs. Bright tile
scattered across a tabletop may inspire a bright linear pattern on a

subdued background. Irregularly shaped pieces of unglazed floor tile may suggest a random pattern brightened with a shiny, glazed bit of ceramic for contrast. The grain of a piece of weathered wood may be repeated by an arrangement of pebbles that surrounds it.

Designs may be completely nonobjective, developed from interwoven geometric or freeform shapes and lines. These should be more than random "scribbles," however; careful attention should be given to developing a clearly defined, unified design with satisfying relationships between shapes, values, and colors. Such a design may be developed from a collage of torn or cut papers which will permit shifting and trial arrangements of elements until a pleasing arrangement is achieved. White, gray, and black construction papers may be used effectively with the added advantage of providing a "working guide" for the placement of light, dark, and medium tones of tile colors.

*Natural forms* such as tree bark, seedpods, flowers, fruits, vegetables, or trees may be treated abstractly with their identifying characteristics exaggerated or distorted for the purposes of design. Birds, animals, insects, and fish—when reduced to basic shapes—make interesting design motifs. Tide pools, rock formations, or the pat-

**Figure 2.13** *Experimental Panel* To achieve variety and interest in a design, experiment in ways of cutting and placing the tiles to achieve different textures and rhythmic patterns and movements. Note the texture achieved by setting the light tiles on edge and how tiles are set *within* the shapes. The circular shapes (top right) were made by nipping away the corners of square tiles.

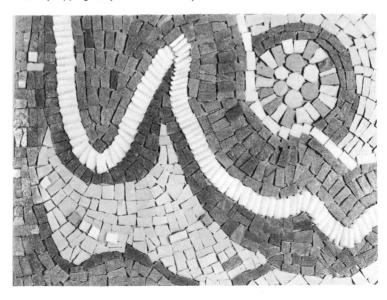

**Figure 2.14**  *Experimental Panels*    On the left, the arrangement utilizes three *different* colors of tile in varied setting patterns. The darkest tiles are generally square cuts and are set flat; the lightest tiles are horizontal half-cuts set on edge; the tiles of medium tone are cut to fill the circular shape.

The panel on the right illustrates how variety may be achieved with tiles of a single color. Note how cuts are varied and used to fill the shapes, how spaces *between* the tiles function in the design.

**Figure 2.15**    (Detail) *Albert Einstein*
A smalti mosaic portrait. Elsa Schmid.
Note how tesserae are set to follow the
planes and contours of the eyes and nose.
Further definition is achieved through
careful handling of color values. Courtesy
the artist.

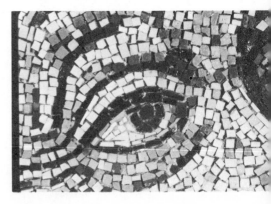

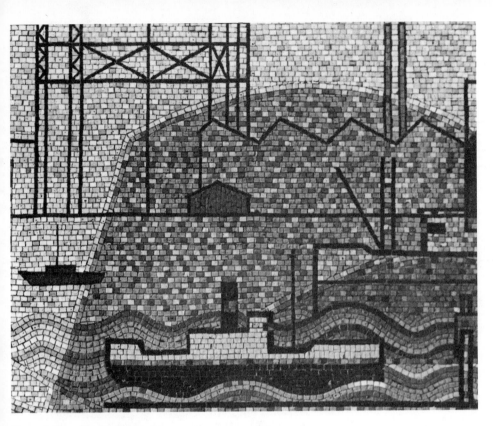

**Figure 2.16** (Detail) *Mural* Los Angeles Police Facilities Building. Designed and executed by Joseph Young. A strong linear pattern on a background of simple shapes. Note rhythms created by setting tiles in wavelike patterns around the ship. Dark vertical lines contrast sharply against the horizontal movement of the tile. Smalti, set by the indirect method. Photo courtesy the artist.

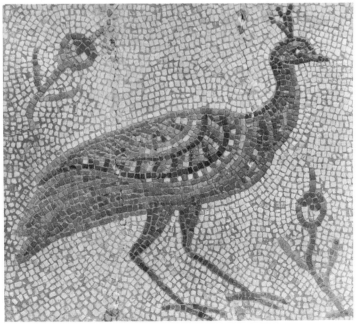

**Figure 2.17** *Peacock* Wall tile mosaic. Early Christian-North African. 4th century. The Metropolitan Museum of Art. Gift of Kirkor Minassian, 1926. Note how the placement of tiles immediately surrounding the bird emphasizes its form. Subtle variations occur in the background, particularly around the head of the bird.

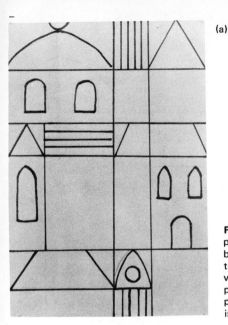

(a)

**Figure 2.18** Use a felt-tipped pen, thick chalk, or crayon to prepare a sketch or cartoon to be used as a guide while tiles are being set. In this sketch on kraft paper, buildings have been reduced to flat, overlapping shapes. A more detailed sketch might indicate values and directions for setting tile. (b) Sample colors may be pasted on the sketch or cartoon to serve as a guide while work progresses. This is particularly important if a complex color scheme is planned or if a variety of materials will be used.

(b)

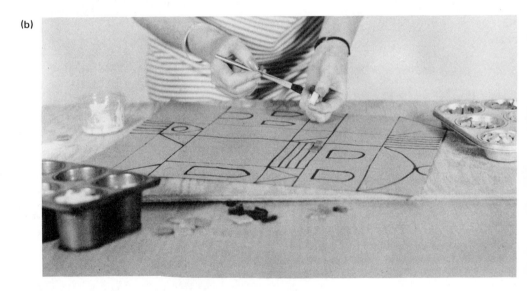

terns in a whirlpool suggest movements and rhythms that may be interpreted in mosaic materials.

Man-made forms of our cities and towns are not to be overlooked. A city skyline is composed of dozens of varying elements: domes, spires, tall columns, stacks, chimneys, towers, water tanks, and flagpoles create a fascinating pattern against the sky by daylight or dusk. New buildings going up and old buildings coming down reveal mosaiclike patterns in their exposed structural elements and wall surfaces.

30

*Aerial views* present ever-changing mosaiclike patterns: mountains, the tracery of rivers, contours of farmland, winding railroads, and the ever-present housing developments are revealed in relationships impossible to grasp at ground level. The lights of a large city, viewed at night from a plane, resemble sparkling mosaic tesserae set in darkness.

*Symbols* used by artists throughout history may be a source of ideas or may be incorporated as elements within a larger composition. Obvious symbols should be used only as they support and strengthen the total design in its meaning and visual impact. Religious and metaphysical symbols are used extensively in art; symbols related to the signs of the zodiac are popular motifs in jewelry design and decorative arts. Artists interested in symbols can find entire volumes devoted to their design and use throughout human history. In designing with symbols, avoid hackneyed or predictable treatments; traditional symbols such as the sun, fish, star, dove, or cross may be altered by the application of patterns or textures and by exaggeration or distortion of shapes and sizes.

**Figure 2.19** *Sketch for Mosaic Design*
Felt pen on kraft paper. A "good" sketch
need not be overly detailed but should
indicate major shapes, values, and some
plan for textures or directions in which
tiles are to be set.

Beginning mosaic designs should be limited to projects of fairly small size. When very large initial projects are attempted, beginners may become discouraged with the result that enthusiasm and spontaneity are lost and another mosaic is never attempted. Small panels in which you explore the possibilities of basic techniques and procedures in cutting and arranging tiles are recommended. These techniques should not be limited to a specific project, however; you should use the techniques learned in an exploratory manner in a project of your own choice and design.

As you begin planning you project, keep basic considerations in mind: *mosaic designs are most successful when they are conceived as two-dimensional pattern without attempts to create illusions of depth or other "painterly" effects.* If the eye is led into the composition, the surface quality is destroyed. The materials must be respected if their characteristics are to be used to the best advantage: mosaic materials are rigid; their colors cannot be blended and used as paints are used. Shapes should be kept simple and bold; values should be clearly defined and colors and lines should be kept to a minimum particularly in the first designs attempted. Simplicity should be the primary consideration in planning.

Proper choices of materials for planning will assist you in creating a successful design. Large sheets of newsprint, tracing paper, shelf paper, or kraft paper are ideal papers for planning. The use of a

**Figure 2.20** Planning can be done with crayon on paper. String is to be used in combination with plastic tile in this design. Courtesy Poly-Dec Co., Bayonne, N.J.

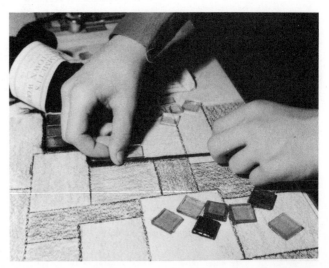

broad drawing tool will eliminate fussy lines that may result when pencils are used: chalks or pastels no smaller than one-quarter of an inch in width, and wide, felt-tipped marking pens are other good choices. The design may be planned in cut or torn paper shapes which may be arranged and pasted on the larger sheet of kraft paper or newsprint. If designs are planned by painting, use a heavy paper and broad brushes, keeping in mind that the design will be completed with mosaic materials. Use paint colors that approximate the colors available in tile or other materials.

When the design has been completed, it should be transferred to the base or support. Large sheets of carbon paper may be used or the back of the paper on which the design has been sketched may be covered with chalk or charcoal. Transfer the design by tracing over the original drawing with a pencil. When the tracing is completed, lift the drawing or cartoon and check the accuracy of the tracing. You can make the faint, powdery lines of carbon or chalk clearer and more permanent by going over them with a sketching pencil or felt-tip pen since they are apt to smudge and disappear as work progresses.

## SELECTION OF MATERIALS

Materials available will have some influence on the types of designs produced. If an unlimited budget has provided a wealth of tile in a wide variety of colors, there is no problem. If resources are narrowed to scrap lots of tile in limited ranges of colors and values, this must be discussed and kept in mind as you plan. Brightly colored tiles may be reserved for accents or focal points while duller or unglazed tiles may be used in background areas. Natural materials such as pebbles and marble scraps present a limited range of earthy, muted tones requiring careful sorting of colors, values, and sizes.

Contrasting materials, used judiciously, arouse interest and create visual surprises, relieving monotony in color or texture. This monotony may be observed in all too many mosaic panels or murals in which the artist has used a single kind of tile, uncut and unaltered in direction throughout the design. The result is often unpleasantly mechanical and static. Either extreme is to be avoided. The finished work should be vital and bold with an "active" surface; it should not be jarring and discordant with each area competing for attention.

Using the cartoon as a guide, select the mosaic material or tesserae to be used. Place tiles or other materials on the cartoon, keeping in mind not only color and texture but the direction or pattern in

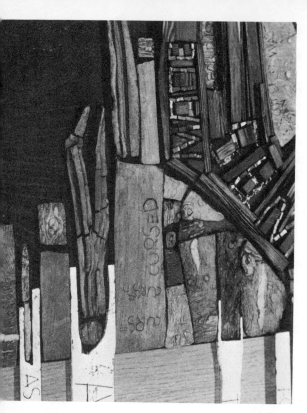

Figure 2.21

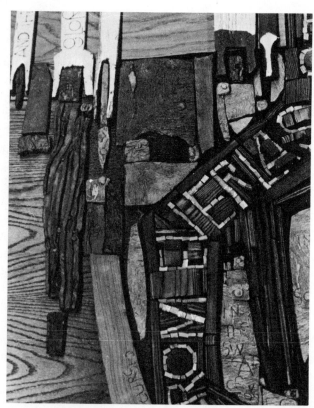

Figure 2.22

**Figures 2.21-23** (Details) *Mosaic Mural* Wood and glass.
Reinhold P. Marxhausen. Photos courtesy the artist.

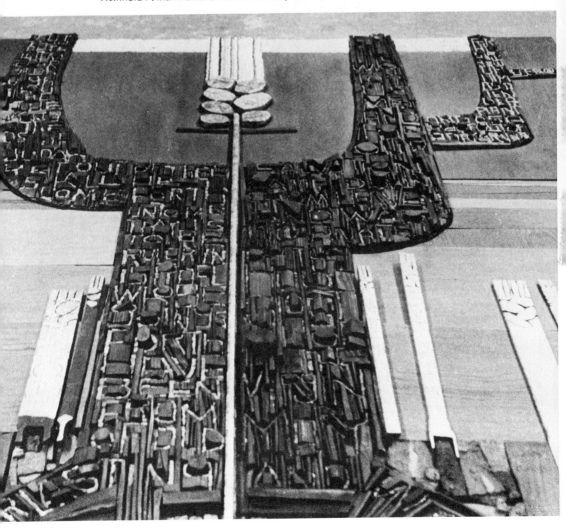

which the material is arranged. Experiment by moving tesserae about, noting the changes that occur as contrasts are created in textures, shapes, and colors. Large areas of solid color may be broken by slight color changes; experiment by adding a few tiles of a related or complementary color. Note the effects created by the small, open areas between tesserae; these can be used effectively in creating direction or movement when tiles are used throughout the design. Experiment with turning tiles on edge to create a raised, ridged texture against a flat area. Variety in the size of tesserae should also be kept in mind: small areas require small tesserae; large areas and backgrounds require larger tesserae. Follow contours closely so that shapes remain clearly defined as originally planned. Avoid changing the direction in which the tiles are laid within a shape. Indicate the direction in which tiles are to be laid by short strokes of chalk or pen.

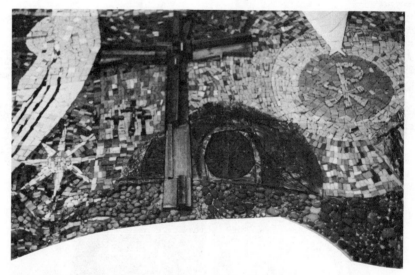

**Figure 2.24** (Detail) *I Believe* Mosaic mural. Lutheran High School, Los Angeles. Robert Sylvester and Gerald Brommer. Contrasts in texture provided by beach pebbles, wood, glass, and terra cotta. Photo courtesy Gerald Brommer.

When the final selection of materials is completed, make note of them on the cartoon or glue samples of tesserae to the cartoon so that choices are not forgotten as work progresses. Keep the cartoon nearby when the design is checked against it. Because mosaic designs are composed of fragments, it is easy for the beginner to become confused and, consequently, lose his design, unless he frequently checks the boundaries of his original sketch. There are times when

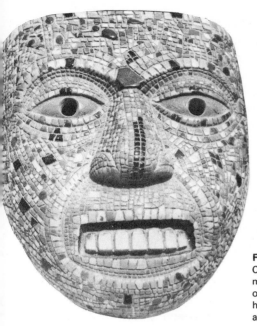

**Figure 2.25** *Mosaic Mask* Mexico. Pre-Hispanic. Turquoise mosaic, with mother-of-pearl forming the teeth and eyes. Wood base. Note how the mosaic fragments are arranged to follow and accent the planes of the face. Photo courtesy Mexican National Tourist Council.

**Figure 2.26** (Detail) *Mosaic Panel* Glen Michaels. Bulova Watch Co., N.Y. Line, texture, value, and movement are controlled by the manner in which tiles are cut and set: some tiles are set on edge, others are cut and set with the cut surfaces facing up. Vertical, horizontal, and swirling movements are created by grouping and arranging tiles in changing, lively patterns. Circuit panels and watch parts provide contrast and visual relief.

the nature of the mosaic material may demand slight changes in the original design: a particular shape or piece of tile doesn't work properly, an area appears monotonous, or a "happy accident" has occurred and must be incorporated—all of these must be anticipated and the necessary adjustments made.

As you become more involved in your work, you will experience the feeling of being "pushed around" by the demands of the materials. This experience marks the beginning of your understanding of the nature of mosaic materials and of mosaic design.

Some limitations or restraints in the use of materials are advisable and should be considered. The novelty of mosaic materials can present problems for the beginner who may be tempted to incorporate a bit of everything into one design. Tiles, pebbles, wood, beads, bits of mirror, stained glass, crushed stone—all are fascinating. Used indiscriminately, too great a variety of materials destroys the unity of a design. A selected material may seem to possess a natural affinity for another quite different material and these two may be combined effectively: pebbles or flat beach stones relate well with weathered wood; stained glass and Venetian glass tiles work brilliantly together. There are no "rules," as such; experimentation provides the best answers.

# 3 Mosaic Materials, Tools, and Equipment

## MOSAIC MATERIALS

Traditional mosaic materials are referred to as *tesserae*—singular, *tessera*—derived from the Greek, meaning four, or "little cube." Since modern mosaic designs incorporate almost any material that can be adhered, the "little cube" definition is scarcely adequate to cover the great variety of materials used by contemporary mosaic artists. This discussion includes many materials other than tile; some are referred to as "natural" or "found" materials, readily available to you at little or no cost. These materials provide exciting possibilities for the mosaicist working in the contemporary manner.

*Smalti*, or *Byzantine* glass, is the aristocrat of traditional tesserae and is preferred by professional mosaicists. Smalti tesserae are irregular in size (approximately ½″ by ⅜″ by ⁵⁄₁₆″) and surface quality, and are available in literally thousands of tints and shades. Their surface irregularity causes the breaking up of light across the

**Figure 3.1** *Tiles* Clockwise from the left: Smalti, Venetian glass, ceramic tile, plastic tile, marme (marble cubes), and, in the center, heavier ceramic and granitex floor tile.

**Figure 3.2** *Panel* Helen Luitjens. Byzantine glass (smalti) adhered with Wilhold glue on wood. Photo courtesy the artist.

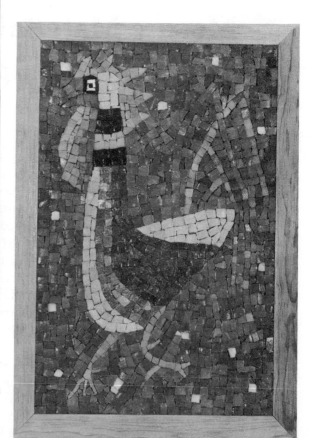

**Figure 3.3** *Rooster* Mexican glass tile set with white glue on Masonite. Tiles are closely set and left ungrouted. The background is gray with scattered bits of yellow; the rooster is in warm tones of red, yellow, and brown.

surface of mosaic design, creating the glittering, changing textural quality so eagerly sought by the mosaicist. Smalti may be used as is, or may be cut into other shapes and sizes. When you are cutting smalti, you can make more accurate cuts by placing the entire tile between the blades. (See "Basic Cutting Tools.") Prices vary with colors and amounts purchased but smalti is one of the most expensive mosaic materials, since tesserae are cut by hand and imported from Italy. Orders may be placed directly with Italian studios or with distributors in this country. Order well in advance of need.

*Marme*, or marble tesserae, are also imported from Italy. Available in a limited range of subtle colors such as rose, blue, and gray, with a matte surface, marble tesserae are quietly beautiful—and expensive. Order from distributors.

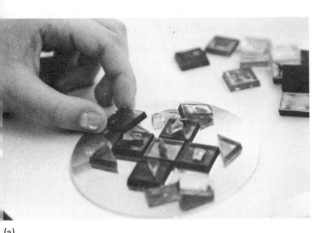

**Figure 3.4**   Plastic tiles may be cut and adhered as other tiles are used or may be fused at 350° F. Here, tiles are arranged for fusing on an aluminum blank. Small mosaic forms made in this manner may be used in jewelry design. In (b) tiles are placed in the sections of an aluminum painting tray for fusing in an enameling kiln. The tiles will fuse and take the shape of the container, forming domed shapes which may be used on a panel, in jewelry, or as decorative elements on a box lid. Photos courtesy Poly-Dec Co., Bayonne, N.J.

(a)

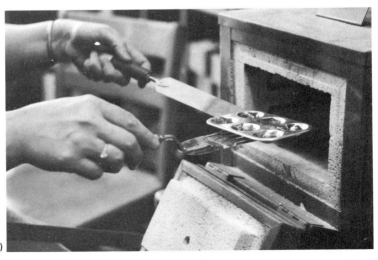

(b)

*Glass tile*, commonly called Venetian tile, is also manufactured in Mexico and in Japan. These popular tiles are three-quarters of an inch square and may be purchased in a wide range of colors, which vary greatly depending on the quality of the product. Glass tiles are sold in bulk, by the pound, or pasted on 12″ by 12″ paper sheets. Glass tiles are not as rich in color as Byzantine smalti but are far less expensive; prices vary with colors.

*Ceramic tiles* are the most popular mosaic material with beginners. They are easily obtained and relatively inexpensive. The most commonly used tiles are square, ¾″ by ¾″, but other shapes are available. They are usually sold pasted to a paper sheet or netting and a wide range of colors—solid and mottled—is available. Ceramic tiles lend themselves to a variety of projects, are relatively easy to cut, but should not be used for outdoor installation since they absorb moisture. Heavier, thicker ceramic tile may be obtained as scrap from tile distributors or tile contractors who set tile. This heavier floor tile, generally subdued in color and finish, may be combined with other types of tile or found materials in a variety of projects. Scrap tile may often be obtained cost-free.

**Figure 3.5** *Geometrics* Ellwood Miller. Ceramic tiles and sawed copper tubing on Masonite set with white glue. The lightest tiles are set on edge, creating a relief surface and adding textural interest; the low areas are grouted. Colors are red, orange, yellow, and white.

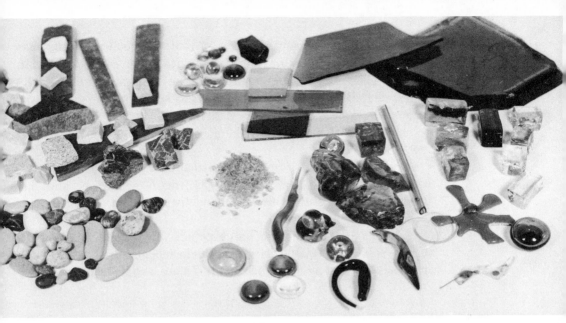

**Figure 3.6** *Stones and Glass* Marble scraps provide a variety of muted tones in red, white, green, and beige; beach pebbles, a range of earthy tones. Stained glass forms range from cullet (center) to sheets, dalles (thick slabs), and a variety of discards from the glass factory. Except for cullet (nuggets), all glass shown here was obtained, practically cost-free, as scrap.

**Figure 3.7** *Phoenix* by the author. Stained glass in epoxy resin. Sheet glass is combined with glass nuggets and scrap. Darker tones are blues, greens and purples; lighter tones are warm reds, oranges, and yellows. Made by the process described on pages 102-4.

*Stained Glass*, in many forms, is currently popular with mosaicists who use it exclusively or combine it with other mosaic materials. Stained glass may be obtained from the manufacturer in sheets, dalles, chunks and cullets (nuggets), or as scrap from a stained glass studio. Depending on its form, glass may be cut and adhered as tile, or in the case of nuggets and chunks, embedded or cast in mastic or mortar.

Other types of glass for mosaics include window glass (spray or brush paint on the back), bottle glass, marbles, mirrors, and glass from discarded costume jewelry, chandeliers, and optical lenses.

*Natural materials* include beach pebbles, driftwood, bits of bark, marble scraps, minerals, shells from the beach, and dried seeds. These materials are best used in their natural state; avoid the use of paints,

**Figure 3.8**   Stained glass on Masonite panel, in progress. The panel, rough side up, was coated with flat white paint for greater light reflection. Glass was adhered with a white glue that is transparent when dry. In the center of the panel, spaces between the glass have been filled with metal paste from a tube. For a more reflective surface, cover the panel with aluminum foil before adhering glass. Spaces between glass may also be filled with aquarium cement or black tile mastic available in tubes.

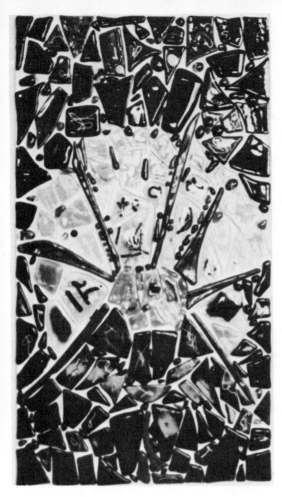

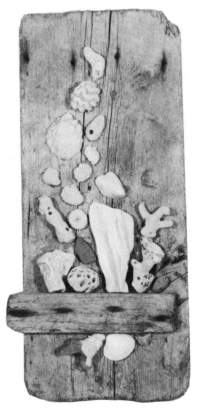

**Figure 3.9**  *Kiln-Fired Glass Panel*  Mildred Vanatter.
For better reflection the panel was painted white and the
glass adhered with clear-drying cement. Photo courtesy
the artist.

**Figure 3.10**  *Gifts From the Sea*  by the author. Shells, coral,
and pebbles on beach wood. The wood was used as found; the other
materials were attached with epoxy cement which provided a strong
bond when applied to the irregular surfaces of the shells and coral.

dyes, and varnishes since these tend to destroy the subtle beauty of
the natural "earth" colors. Wash or brush the materials to remove
soil and sand or other debris that might prevent proper adhesion.

*Found materials*, when used creatively and with certain restraint,
provide contrast, surprise, and interest in a design. Select objects for
interesting shapes and varied surface qualities: watch parts; sheet
metal; small metal shapes such as gears, nuts, bolts, and nails;
buttons; spools. Clean or finish the object so that it will adhere

**45**  securely.

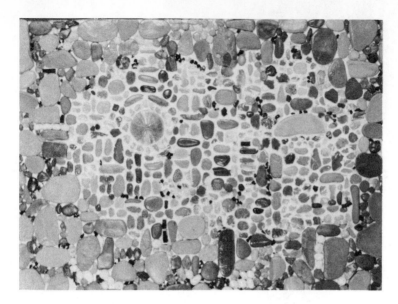

**Figure 3.11** *The Cape* by the author. Pebbles set in white glue on plywood. A thin grout was poured over the panel, then almost completely removed. Bits of crushed stone in jet and amber add sparkle. The surface of the panel was rubbed with liquid floor wax.

**Figure 3.12** *Found Materials* The textures and shapes in discarded materials provide raw materials for the contemporary designer of mosaics: coral and shells, metal tacks, gears, and oarlock, discarded parts of musical instruments, chain, clam shells, metal scraps, flooring nails, costume jewelry—all may be used in mosaiclike designs.

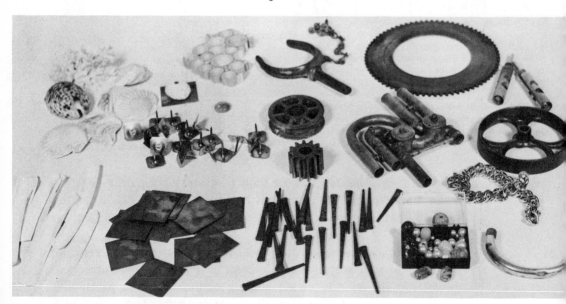

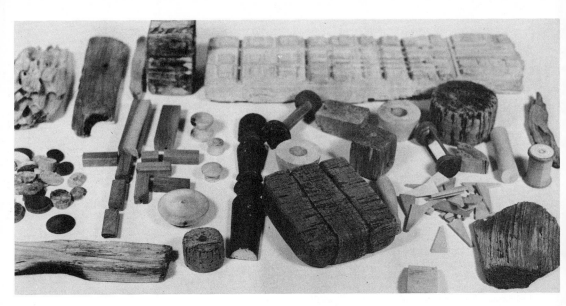

**Figure 3.13**  *Wood and Cork*    An almost unlimited range of shapes and textures are discovered in wood and cork found on the beach, in the woodwork shop and around the house. You can further alter wood shapes by sawing them into sections, by staining them, and by painting.

**Figure 3.14**  *Rondo*    Chris Lemon. Found objects, mostly wood. The chain hangs loosely and may be repositioned if the panel is displayed horizontally.

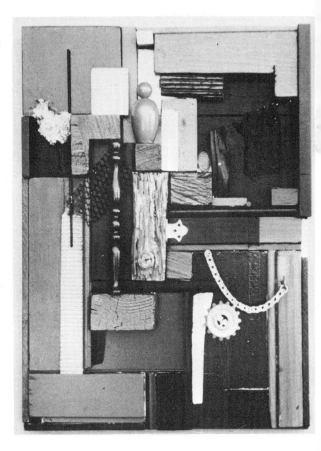

47

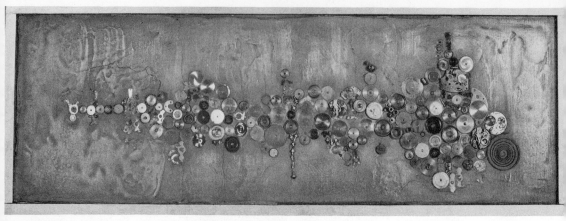

**Figure 3.15**  *Tempus*  by the author. Watch parts set in a thin layer of aluminum metal paste on plywood. After the paste hardened, the entire surface was burnished with emery cloth to produce highlights on the background and the silver and brass parts. The wood strip frame was painted silver. 9″ x 25″.

**Figure 3.16**  *From Schoodic Point*  Driftwood, 33″ x 18″, by the author. Found and sawed shapes on a plywood base that was painted gray. The only finish was thinned acrylic medium brushed on to seal the surfaces of the wood.

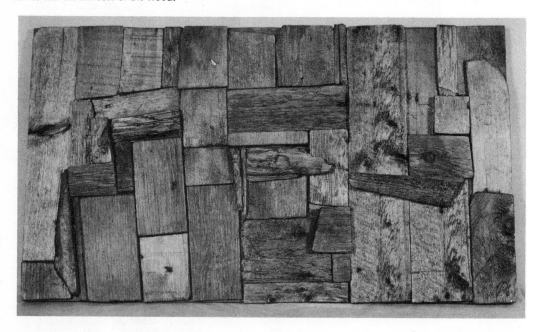

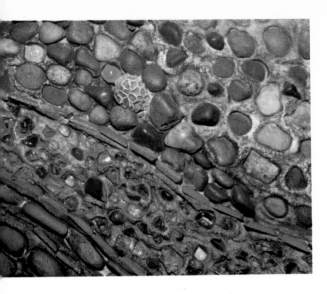

(Detail) *The Wave* by the author.
Pebbles, stained glass, and Venetian
glass set in magnesite cement on
plywood. Photo by Elizabeth Walton.

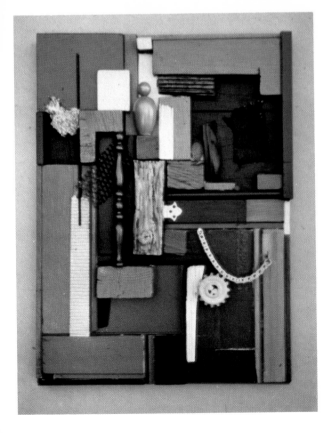

*Rondo* Chris Lemon. Found objects,
mostly wood. Courtesy the artist.

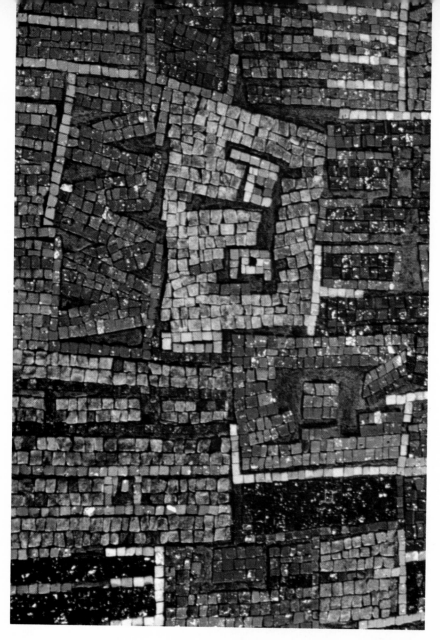

(Detail) Mosaic designed by Corrado Cagli and executed in smalti by S. Cicognani. Shown at the Exhibit of Modern Mosaics at National Museum, Ravenna. American Crafts Council.

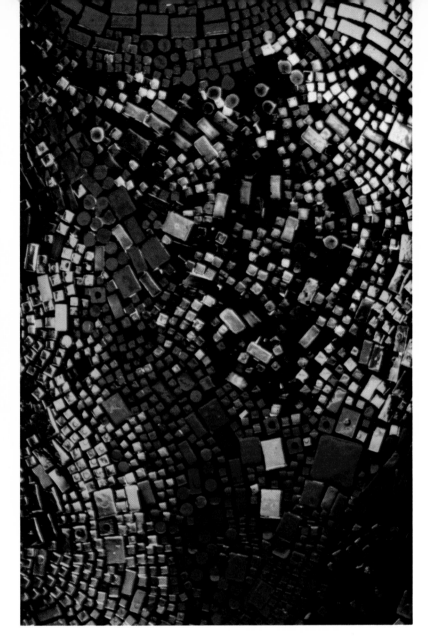

(Detail) *Fire-wall*   Thelma R. Newman. Collection. Willimantic, Connecticut State College. Mosaic of cast polyester resin. Photo courtesy of Poly-Dec Co., Bayonne, N.J.

*Suntown*  Elsa Schmid. Fresco and smalti mosaic. Courtesy the artist.

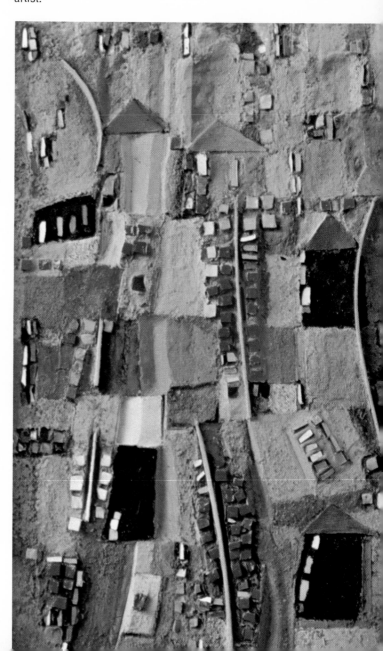

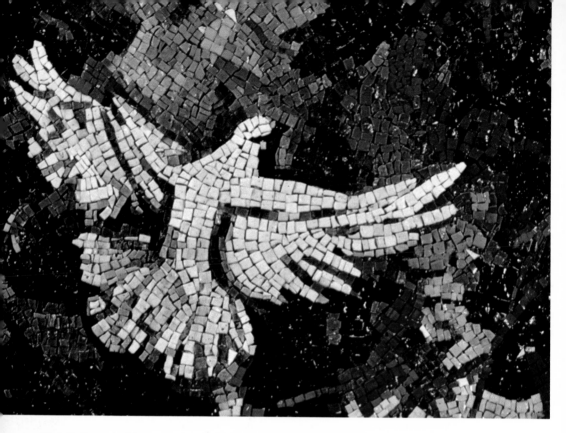

(Detail) *Doves in Flight*   Renato Guttuso. National Museum,
Ravenna. American Crafts Council.

*John*   Reinhold P. Marxhausen. Ceramic and glass. One of
a series, *The Twelve.*

*Window*   Sterling Silliphant. Faceted and cast stained glass dalles. Photo courtesy
Judson Studios, Los Angeles, California.

(Detail) Mural, wood.   Reinhold P.
Marxhausen. State House, Lincoln,
Nebraska.

*Dome* Roger Darricarrere. St. Luke's Chapel, Santa Ana, California. Courtesy the artist.

*Papers and boards* are always available and, when used imaginatively, are especially popular with younger beginners. Provide a variety: wallpaper, tea papers, blotters, colored magazine ads, paper towels, gift wraps, and metallic-coated papers. Also available are colored poster board, boards painted with leftover paint mixes (acrylics are best), and other boards of varying thickness and texture. You can cut these in a variety of shapes and sizes; tiny, uniformly sized snips of paper or board become tedious busy-work that may be abandoned. Individual projects should be kept fairly small; group projects may be larger.

*Plastic tile* is the newest addition to commercially prepared mosaic materials. The wide range of colors approximates those of stained glass. Tiles are approximately ¾″ by ¾″ and are sold in bulk, in single colors or assorted color packs. Ordinary cutters or nippers are used to shape the tiles or they may be broken in random shapes with a hammer. The tiles are most effective when mounted on glass or sheets of rigid, transparent plastic. Translucent plastic provides a softer, diffused light. Adhere with clear-drying acrylic, casein, or epoxy glues.

Plastic tiles arranged on aluminum or Pyrex surfaces may be fused in a kitchen-type oven at 350°F.

*Handmade ceramic tile* may be prepared inexpensively from ceramic materials available in the average classroom. Clay slabs in the desired thickness are rolled cookie-fashion, glazed while still damp, then cut into various shapes and fired in the usual manner. Tiles may be cut into any shape, including freeforms and shapes to fit specific areas within the design that is planned. Surfaces may be matte or gloss, textured or plain.

If a textured surface is desired, place burlap, mesh, screen, or other similar materials on top of the clay slab and roll the surface evenly and firmly with a rolling pin or sturdy cardboard tube. Scratching the surface of the slab with corrugated metal, nails, or sticks produces another type of texture. Gently brush away bits of excess clay with a soft cloth or brush.

Roll small pieces of clay between the palms of the hands to make clay "nuggets" which may then be flattened and textured with sticks, pencils, erasers, metal screws, or bisque-fired clay stamps.

Glaze will not adhere to freshly wet clay but may be applied when the clay is damp. Permit clay to dry for two or three hours, then test the degree of dampness. Fire when clay has air dried.

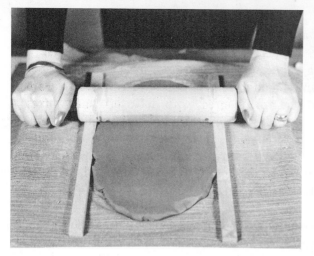

(a)

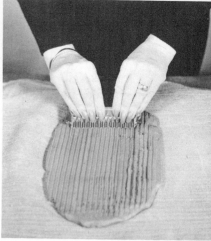

(b)

**Figure 3.17** *Demonstration:*
Ceramic tesserae from a clay slab.
(a) After thorough wedging, clay is rolled
on a heavy cloth for easier removal of cut
shapes. (b) The wood strips are removed
and the slab is textured with a corrugated
vegetable garnisher. (Metal screen, sticks,
or other improvised tools may be used
effectively.) Loose bits of clay should be
brushed from the textured slab before
glaze is applied. (c) After approximately
two hours, glaze is applied with a soft
brush. This short drying period is
necessary because glaze will slide off the
surface if the clay is freshly wet. (d) While
still quite damp, the clay is cut into small
slabs of various sizes. Freeforms or shapes
designed to fit specific areas of a design
may be made in this manner. After
drying completely, the shapes are ready
for firing in a ceramic kiln.

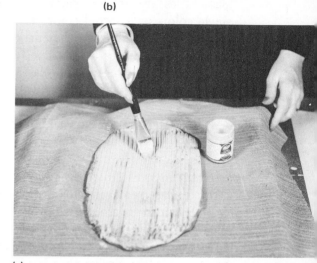

(c)

**50** (d)

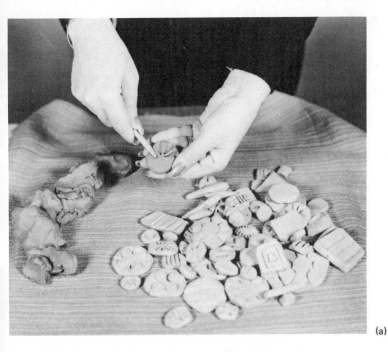

(a)

**Figure 3.18** *Handmade Ceramic Tesserae* (a) A flattened clay shape is textured with the point of a pencil. Glaze may be applied in two to three hours while the surface of the clay is still damp. After drying completely, the tesserae are fired in the usual manner. Dry slowly to avoid warping. (b) The ceramic tesserae shown here were textured with a variety of found tools: kitchen gadgets, an eraser, edge of a scallop shell and a meat skewer. Some of the shapes were cut from slabs, plain and textured; long beadlike shapes were rolled in the palms of the hand. Ceramic tesserae of this type may be used throughout a mosaic or combined with other materials such as standard ceramic or glass tile, or with wood shapes.

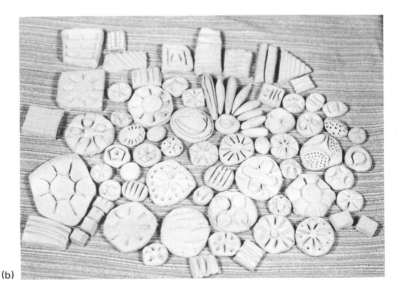

(b)

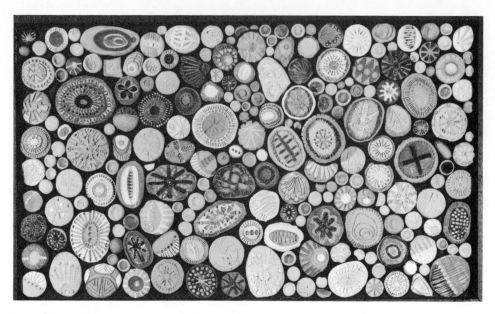

**Figure 3.19** *Circum* Ernest Andrew Mills. Mosaic of individual clay shapes with slip decoration. Photo courtesy Vincent Popolizio.

## BASIC CUTTING TOOLS

The basic tools necessary for mosaic art are few and quite elementary. A cutting tool for shaping tiles or other material is essential but beyond that the beginner's needs are simple. The advanced mosaicist who wishes to explore more complex techniques and to attempt more demanding problems will want to expand his collection of tools.

*The "hardy" and cutting hammer*, also known as the "hutch" and scaling hammer, are the oldest mosaic cutting tools. The hardy, or hutch, is basically a wide metal blade set into a sturdy base with the cutting edge of the blade extended three or four inches above the surface of the base. Following an old tradition, Italian mosaicists embed a wide chisel in the end of a log cut to knee height, which is a comfortable height for the seated worker. The tessera, held between the thumb and forefinger, is placed wide side down across the blade at the angle desired. The blade of the hammer is brought down sharply on the tessera directly above the line of the hutch blade.

There is little need for these traditional methods involving bulky bases not readily accessible to amateur mosaicists. Heavier tools are particularly useful for cutting floor tile, marble scraps, or thicker tiles that are difficult or impossible to cut with tile cutters or nippers.

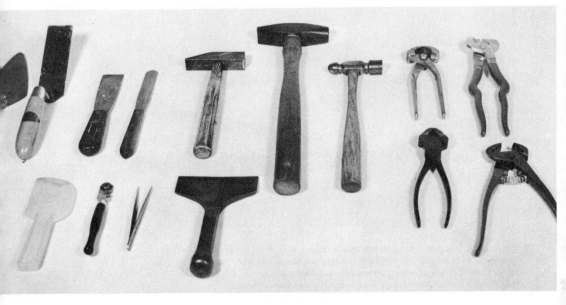

**Figure 3.20** *Tools* The beginner's needs are simple: a cutter, or nipper, for tile; a hammer; a glass cutter, and a tool for spreading mastic. The tools shown here include, from the top left: mason's trowel, plasterer's trowel, putty knife, handmade hammer from a school's metal shop, sheet metal hammer, ball-peen hammer, four types of cutters and nippers, and, from the bottom left, a screwdriver, plastic scraper, glass cutter, tweezers and a brick chisel. The latter, secured in a vise, makes an excellent tool for breaking floor tile.

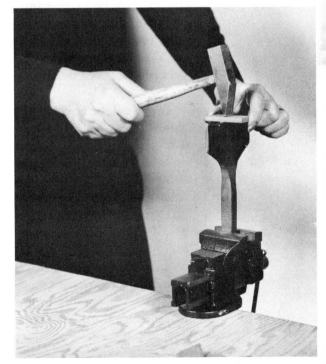

**Figure 3.21** Cutting floor tile on a brick chisel secured in a vise. Hold the tile straight across the blade of the chisel, then strike sharply at a point directly above the blade.

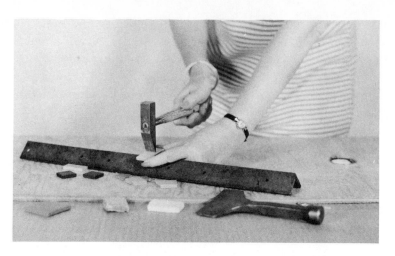

**Figure 3.22** Scrap floor tile, too heavy to be cut with nippers, can be broken over angle iron. Hold the tile straight across the iron and strike sharply. With practice, some fairly accurate cuts can be made. For another cutting tool, place a wide brick chisel (foreground) upright in a vise and break tiles across its cutting edge. Use a sharp-edged hammer like the one shown for best results.

Improvise a hardy by embedding a cold chisel or brick chisel in a wood block or bucket of cement. If this is not practical, break the tile over a piece of angle iron that has been hardened. A hammer need not be the traditional scaling hammer: a sheet metal hammer, shoemaker's or brick hammer may be used. A brick chisel may be placed upright in a vise and the tile broken over the cutting blade with a hammer.

You can break heavier scrap tile into random shapes by placing it between pieces of burlap and striking it with a hammer.

*The glass cutter* is used for cutting sheet, or flat pieces of glass. A good ball-end cutter is the most useful type and can be purchased at hardware stores for less than a dollar. (Glass cutters, like tile cutters, do not actually cut glass; they weaken it so that breaking can be controlled or directed.) Special cutters for cutting circles are available from glass craft supply companies.

There is no absolute rule for the right way to hold the glass cutter; hold it in the way that is most comfortable for you. Remember that the cutting wheel should be held perpendicular to the glass, otherwise a beveled edge will result. Great pressure is not needed. Firm pressure that produces a continuous white line on the surface of the glass is sufficient for proper scoring of the glass. After the glass is scored, turn it over and apply pressure with the thumbs to the scored line, or tap the reverse side with the ball end of the cutter.

Cutting curved lines and circles requires practice and some planning. Leave an inch or two of margin around the curved shape and remove this margin in sections rather than attempting to remove it in one piece. Score radiating lines from the shape to the edge of the glass sheet. Turn the glass over and apply light pressure to the fractured lines removing the margin in sections.

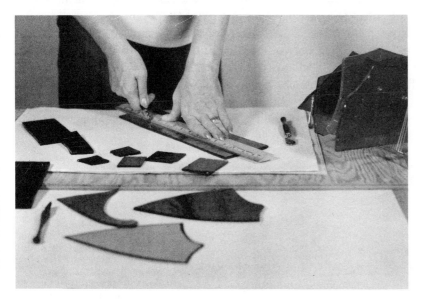

**Figure 3.23** *Cutting Glass* Holding the cutter in a comfortable manner, guide it firmly and evenly across the glass to score a white line on the surface. Complete the breaking by applying pressure with the thumbs to the scored lines. If the glass is thick, fracture the glass by tapping the reverse side with the ball end of the cutter, then apply pressure. A metal-edged ruler is helpful in cutting straight lines. Use a paper pattern (foreground) when cutting curved lines.

*Tips on cutting:*

1. Cushion the worktable with a pad of newspapers, felt, an old blanket, or sheet cork.
2. Be sure that glass to be cut is clean. Wash with soap, rinse, and avoid fingerprinting the glass. Wash with alcohol to remove stubborn stains or smears.
3. Use a steel-edged ruler to assist in cutting straight lines; use thin cardboard patterns to guide the cutting or curved lines and shapes.

*Tile cutters*, or nippers, are the basic and most widely used tools for cutting commercially prepared tiles. These are available in several

styles and prices vary with quality. Some imports are quite inexpensive and, if given proper care, serve adequately. Best quality cutters are those with carboloid-tipped cutting edges, longer, cushioned handles, and a spring return that automatically reopens the cutting jaws.

To cut or nip the tessera, hold it in the left hand at right angles to the cutting blades; with the right hand grasp the cutter far up on the handle, open the cutting edges and close them on the tessera about ⅛ inch over its edge. Apply pressure sharply and the tessera should break cleanly into halves. Practice cutting: if the cutter is placed too far over the tile it will shatter; if placed too near the edge, shattering will also result. Once the tile is cut into halves, it may be cut further into quarters. Placing the cutters diagonally will produce triangular cuts. When cutting beveled tile, hold the tile so that the beveled edge faces up.

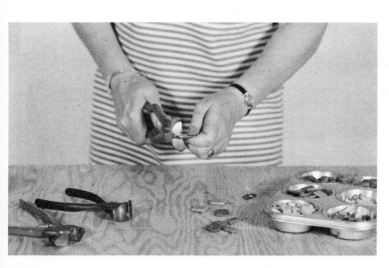

**Figure 3.24**   *Cutting Tiles*
Hold the tile firmly between the thumb and forefinger and place it at the angle at which a fracture is desired. Because the nippers shown in use are side-cutting, the tile is placed about one-eighth inch into the jaws. The tile is not actually cut, but fractured. The nippers in the left foreground are an improved type: the tile is inserted all the way into the jaws, permitting a more accurate cut, and the spring automatically releases the handles after a cut is made.

**Figure 3.25**

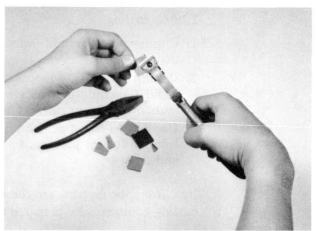

Certain types or brands of tile are more difficult to cut than others; glass tiles are more apt to shatter than ceramic tiles; some colors, especially in glass, are more difficult to cut. Smaller bits are more difficult to shape and handle and are best avoided by the beginner.

## RELATED TOOLS AND EQUIPMENT

Not all of the tools and equipment listed here are essential; some are highly desirable for making work easier and more efficient.

**Figure 3.26**

*Spatula or palette knife.* Use to spread mastic, to apply grout, for scraping away dried cement, and dozens of other jobs.

*Trowel.* Choose a pointed trowel (mason's) or square-ended (plasterer's) trowel, depending on your purposes. Either may be used to spread cement or mortar.

*Hammer.* Use for breaking tile and for simple carpentry jobs, such as building frames for mortar; use in finishing edges in attaching molding or stripping.

*Screwdriver, or narrow chisel.* For removing mistakes after cement has dried, for chipping dried cement or mastic from the support.

*Kraft paper, tracing paper.* For planning and transferring designs.

*Steel wool, sandpaper, or emery cloth.* For polishing, cleaning.

*Tongue depressors.* For mixing and spreading practically everything.

*Rubber squeegee.* Helpful in spreading grout. Rubber spatula may be adequate.

*Clean-up and mixing equipment.* Should include plastic bowls, buckets, sponges, rags, and lots of newspapers.

*Safety equipment.* Eye goggles for protection against flying bits of glass and tile. Gloves for handling glass fragments and sorting glass. Dustpan and brush for brushing up glass fragments.

## ADHESIVES AND SETTING MATERIALS

If mosaic projects are to be truly permanent and if they are to fulfill their intended functions, it is important to choose the adhesive that will best serve the purpose. In selecting the adhesive consider the nature of the materials used (porous, nonporous, degree of transparency, how the piece will function (wall panel, counter top, tabletop), and where the finished piece will be displayed or used (indoors, outdoors, near heat).

### *WATER-SOLUBLE ADHESIVES*

#### *Casein Glues*

Casein-based glues are among the most versatile adhesives and are widely available under different brand names. They set up fairly quickly, are easy to apply, and are used extensively by beginners and in the classroom. Tiles, smaller pieces of glass, pebbles, seeds, and

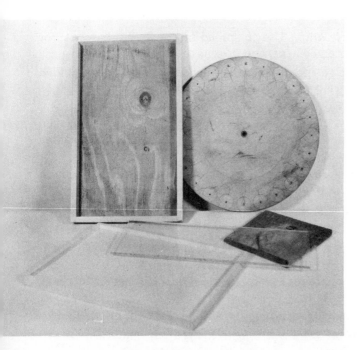

**Figure 3.27**  *Bases and Supports*
From top left: framed plywood, a repair shop discard, ¼-inch plastic, framed and painted Masonite, and a weathered length of board from the beach.

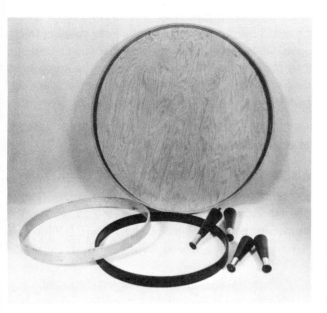

**Figure 3.28** A musical instrument repair shop provided these circular "frames" for mosaics—they are discarded parts of drums. Plywood has been fitted into the largest rim; with legs (foreground) attached, it becomes a sturdy base for a mosaic table.

many found materials may be adhered with casein to backings of plywood, Masonite, or other hard boards. To adhere heavier or less porous materials, apply glue generously to the backing, and be sure that the material being adhered is pressed on firmly. Most white glues are transparent when dry; some retain a slightly milky tone when thickly applied. If a piece is not to be grouted, this should be kept in mind and materials placed closely together or else the dried glue will show. Casein glues are water-resistant but not waterproof.

*Paste, Mucilage*

Ordinary school or library paste and mucilage are suitable for paper and cardboard mosaics. Do not attempt to adhere glass, tile, or heavier materials with paste; it does not provide a strong, permanent bond.

A water-soluble paste should be used in designing mosaics by the indirect method. (See Chapter 4.) In this technique, the tiles or other materials are pasted face down on a heavy paper, then turned over into a prepared bed of mastic or mortar. The water-soluble paste is used in the preliminary step only; it does not serve to adhere the mosaic tesserae to the support. After the mosaic has been leveled and the setting bed partially set, the paper is dampened to soften the paste and carefully peeled away.

Experiment to determine the best paste to use in the indirect **59** method. It must be strong enough to prevent materials from

dropping off the paper backing before they can be embedded, yet it should be easily removed. This recipe for a simple flour paste is fairly reliable: blend one part flour with about eight parts water. Boil for five minutes. Strain to remove any lumps. Make only the amount of paste that will be used in a short while. White school paste is usually adequate for small panels.

### Polyvinyl Acetate Glues

These glues, another type of "white glue" work best with porous or textured materials. If nonporous materials are used in the design, press the material firmly into a generous application of glue until excess glue rises around the bottom edges of the material. This will lessen the chances of its becoming dislodged and falling from the surface.

Polyvinyl acetate glues are water-resistant but not waterproof.

**Figure 3.29**   *Decorative Mosaic Plaque*   by the author. Venetian glass tiles on wood shape sawed from pine. White glue was used to adhere tile. Dark owl was cut from stained walnut.

## WATERPROOF ADHESIVES

### Mastics

Rubber-based mastics are recommended for beginners when a strong, waterproof bond is desired. Puttylike in consistency, mastic spreads easily and may be applied directly to the support and the materials pressed into it, or each separate piece of material can be "buttered" on the back, then pressed firmly in place. Another

**Figure 3.30**  *Mosaic Bowl*
Edith Crawford. Ceramic tile in
solid and mottled colors applied
to wood bowl with tile mastic.
The design was grouted and the
surface waxed.

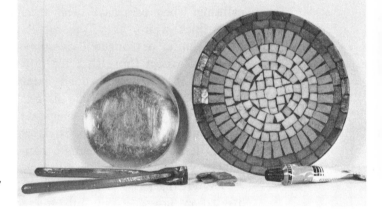

**Figure 3.31**  *Mosaic Plate*  by
the author. Glass tile on aluminum
base, set with black rubber-base
mastic. The design in reds, oranges,
and yellows was set from the edge
inward.

advantage is that mastics do not dry so quickly that changes are difficult to make.

When buying mastics, read the label carefully to determine the "open time"—this refers to the period during which tile may be placed into the spread mastic.

An added advantage of mastic is that, because of its "tackiness," it may be used on vertical and curved surfaces where a thinner adhesive would run, carrying tesserae with it.

Mastics are available in beige tones, brown tones, and in white. When transparent materials such as glass and plastics are to be adhered, use white mastic; it will provide greater light reflection. Some rubber-base mastics are black.

Some mastics (Ply-Bond, Black Magic, Bond Master) work successfully on metals. Mastics may be used in both direct and indirect methods.

### Household Cements

These widely used cements are often referred to as "all-purpose" cements but should be used with caution in designing mosaics. As they age, they tend to become brittle and materials adhered with them, especially nonporous materials, will crack off the support. Their transparency makes them popular adhesives for glass but the bond is unreliable. They are best used for porous materials.

### Modeling Pastes

These versatile pastes were formulated by paint manufacturers to provide a material for heavy impastos and textured surfaces in painting. Their uses have been extended in all areas of art. Resembling thick white putty, the pastes are easily spread with spatula, palette knife, or tongue depressor and will adhere practically all materials except those that are oily, greasy, or waxy. (Nonporous materials should be embedded deeply.) They produce an extremely strong bond for heavy mosaic materials and are especially effective in adhering irregularly shaped elements such as chunky marble scraps, glass chunks, and driftwood. Their whiteness provides light reflection that is desired when transparent materials are used. The paste may be used on vertical or curved surfaces.

If modeling paste is applied thickly and the materials to be embedded are pressed firmly into it, ridges of paste will rise up around the material and create a depth and texture that is most effective.

Modeling pastes may be colored by the addition of almost any type of paint except oils; acrylic paints are recommended since they are compatible with the paste and are permanent in color.

Sand, gravel, or crushed stone may be sprinkled over and pressed into a layer of acrylic paste.

Modeling pastes are manufactured under several brand names and may be purchased in small or large amounts. Although water-soluble in their paste form, they are waterproof when dry. Such paste sets up rather quickly; spread it in small areas where mosaic materials will be adhered within 5 to 10 minutes. Keep tightly covered!

Modeling pastes are relatively expensive but useful for special problems and small projects.

## CEMENTS AND MORTARS

Until the development of modern adhesives, traditional mosaics were set almost exclusively in cement and sand mixtures and some professional contemporary mosaicists, preferring traditional methods, still use them extensively. Cements and mortars provide excellent permanent setting beds, adaptable to both direct and indirect techniques, but are comparatively heavy. Use them for small projects.

*Ready-mixed cements* are recommended for the student or amateur mosaicist. They are readily obtainable and need only the addition of water. (Follow manufacturer's instructions.) Projects should be kept rather small—two to three square feet—since cement is quite heavy. The addition of small amounts of an aggregate, such as Vermiculite, will make a lighter-weight panel without reducing its strength too greatly.

Cement colors, available where cements are sold, may be added to color the mixture. Do not use links or "school colors" of any type—these are "fugitive" in nature and will fade.

Formulae for mixing cements and mortars vary; some mixes are "trade secrets" with mosaicists. The following proportions may be used by the beginner who prefers to mix his own:

*Basic mortar recipe:*

Two parts cement
Six parts sand
One part hydrated lime (omit lime, if project is installed outdoors)

**Figure 3.32**    A handy wood frame for making mortar bases and sand casting. A metal latch and a hinge on the outside of the diagonally opposite corner make the frame easy to remove when the setting bed has dried. Such a frame should be at least 4 inches deep. To use, wax the inside of the frame and set it on waxed paper or a sheet of plastic, then proceed with preparing the setting bed of sand and plaster or mortar. (The frame is propped up to show latch detail more clearly.)

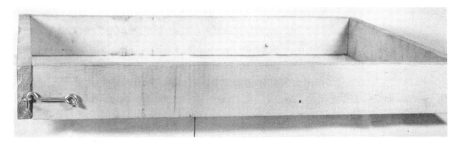

Add water until the mix will stand up on a trowel. A slight film o
water should show on the surface of the mortar. Use less water i
lime is added. A stronger setting bed may be desired if smooth o
nonporous materials such as glass shapes are to be embedded or if a
thin setting bed is planned. A cement bonding agent, such as liqui
latex, is then used. Various types of bonding agents are manufac-
tured but the liquid latex is simpler to use: merely substitute the
latex for the water required and mix to the same consistency.

Thicker cement beds require some reinforcing: pour cement in
two layers, placing galvanized wire mesh or hardware cloth between
the layers. Cut screen or mesh about one inch smaller, on all sides
than the dimensions of the retaining frame. When working with
mortars and cements keep these simple precautions in mind: lime
produces a more workable mixture but should never be used if the
project is to be used or installed out of doors. Mix all dry ingredients
thoroughly before adding water or liquid bonding agents: this appli
to aggregates, cement colors, and to any other dry additives.

*Magnesite cement* is a versatile cement favored by many profes-
sional mosaicists. It is not economical for a single or small projec
since the ingredients must be purchased in bulk. For the seriou
beginner eager to expand his working knowledge of cements, i
provides some worthwhile advantages. It may be spread thinly, to $\frac{1}{}$
inch without cracking; it may be used over armatures of papier
mâché, mesh, or wire; it may serve as both adhesive bed and grout; i
takes cement colors well and is extremely hard. Large panels should
be reinforced with galvanized screening or hardware cloth or should
be coated with a bonding agent to insure a good bond with the
backing.

Magnesite is an extremely versatile setting bed, permitting a wide
use of "unlike" materials of irregular sizes, shapes, and textures. It
may be applied in thin layers or applied thickly.

A variety of mosaic materials may be embedded in magnesite, but
do not use metal objects. Only galvanized metal should be em-
bedded, since magnesite corrodes other metals, producing stains

The dry cement is mixed with a solution of magnesium chloride
crystals instead of plain water. This solution may be purchased pre-
mixed, or the crystals may be purchased and mixed with water as the
need arises. The density of the solution is important and the beginner
is advised to purchase the ready-mixed solution from a supplier of
basic chemicals. (Five-gallon size available.)

Magnesite cement may be used in both direct and indirect tech-

niques. In the direct method, if an area of cement dries before the design is completed, wet the dried portions before applying fresh, wet cement adjacent to, or over, the dried areas.

Despite its popularity, magnesite cement is not readily available in all areas of the country; large, urban areas may have only one distributor. (The mosaicist searching for magnesite cement may find it helpful to know that it is also called "oxy-mag" cement, Sorrell cement, or Woodstone.) Dealers who sell flooring materials used in commercial installation are apt to stock magnesite. The cement is also used on decks of ships, and companies dealing in marine work often stock it.

All magnesites are not alike: some are manufactured for indoor installations; others may be used for outside installation and are waterproof. Color may be bluish, off-white, or beige-tone. Magnesite is inexpensive for large panels or when used by an entire class of students.

Store magnesite in moisture-proof containers. Do not use metal containers. Plastic containers are ideal.

*Joint-system cement* is an easily mixed, inexpensive setting material that is recommended for beginners or very young students. Add the dry cement to clean warm water and stir until the mixture is thoroughly wet. Set aside for thirty minutes, then stir again. The cement is then ready for use. Change the consistency by adding either dry cement or water; color with mineral oxides. Joint-system cement is available at hardware stores and at building supplies centers.

*A more accurate term for plastics* is "synthetic resins." These provide the only really new mosaic materials. Scorned by many traditionalists, the new liquids and pastes have been eagerly adopted by other mosaicists who see them as the means for further exploration of their art. Many of these materials demand extreme care in handling and a technical knowledge exceeding the interest of teachers and students. The materials listed below are those that may be used constructively, safely and at comparatively low cost by the beginner.

*Epoxy cements* are generally sold in tubes and come in two parts: a clear resin and a hardening agent, or catalyst, which is mixed with the resin to produce a thickish paste of extraordinarily strong adhesive qualities. The quality of primary interest to the mosaicist is that the cement will solve many difficult bonding problems: irregularly shaped heavy materials may be adhered to practically any

**Figure 3.33** *Glass and Polyester Resin Medallion* A metal
embroidery hoop was used as a retaining frame for poured resin.
The wire hanger was inserted through a hole drilled in the hoop
before the resin was poured. (For pouring technique, see Chap. 4.)

surface without the dangers of their becoming loose or falling off the
backing: "unlike" materials, porous and nonporous, may be securely
bonded with a small amount of the cement. Special epoxy cements
are available for bonding metals. The epoxy cements commonly
available in art, craft, and hobby shops set very quickly, usually
within a half-hour. The cement is weatherproof.

Larger, bulk quantities may be purchased directly from the
manufacturer. Slower-setting epoxy cements for special projects may
be specially ordered from manufacturers.

Use acetone to clean tools, accidental spills, and hands. Wash
hands, thoroughly, with soap and water and avoid prolonged contact
of epoxies with skin. Use epoxy cements and resins in a well-

ventilated room. As with any material, there is no danger in epoxy materials as long as basic precautions are used.

*Epoxy resins and polyester resins,* intended for pouring and casting, are not sold in tubes but in larger containers, usually plastic bottles of one pint or one quart size. (Larger sizes are available.) Like the epoxy cements, they are a two-part material, resin and catalyst or hardener. Proportions of resin and catalyst used vary with setting time desired; follow the manufacturer's directions meticulously. These resins may be poured within a retaining frame to provide an adhesive setting bed or they may be poured over stained glass and other materials prearranged within the frame. Because of their transparency, resins are particularly desirable for use with stained glass or transparent plastic materials that benefit by the unobstructed passage of light.

Epoxy resins and polyester resins differ somewhat: epoxy resins are generally stronger and will not shatter, shrink, or discolor. Polyester surfaces are more easily scratched or marred in use and tend to shrink upon curing or hardening; epoxy surfaces are practically impervious. Both types of resins may be colored with dyes made especially for that purpose; common dyes or inks should not be used. Epoxy may be colored with mineral oxides.

Both types of resin are comparatively expensive but, because of their strengths, are economical in use and solve many bonding problems for which traditional adhesive and setting materials are ineffective.

*Metal pastes,* or "liquid" metals, can provide an all-in-one setting bed and grout for embedding small, comparatively lightweight mosaic materials such as bits of stained glass, tile, and thin metal shapes such as watch parts or wire. For proper drying, the paste should not be applied in layers thicker than ⅛ to ¼ inch at a time, hence the limitation on the size and weight of materials to be embedded.

Fairly rigid panels are required; ⅛- to ¼-inch hard board is recommended. Spread the paste evenly on the backing with a palette knife or similar tool, smoothing the surface slightly as the paste is applied. The paste sets quickly; work in small areas, setting the mosaic materials before a "skin" forms on the surface of the paste. Push materials down firmly, so that the paste works its way slightly up the edges of the tile, glass, or metal shape: this will insure better adhesion, and the "ridges" of paste that are formed create an interesting texture over the surface of the design.

A special solvent, available from the manufacturer, may be used to thin the paste. Thin applications may be brushed over mosaic materials if an all-metallic surface is desired.

After the paste is thoroughly dry, rub it briskly with steel wool or emery cloth to bring out true metallic glints; create highlights by burnishing the "ridges" of paste with the bowl of a spoon.

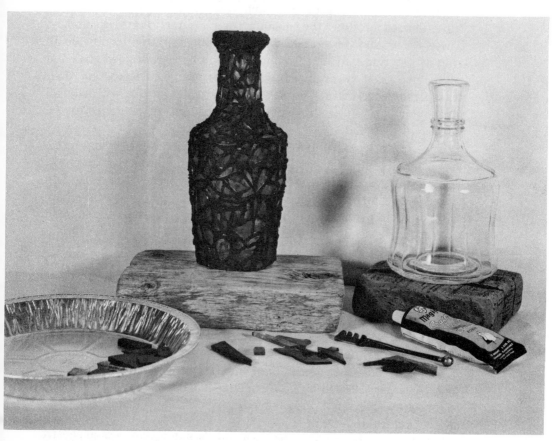

**Figure 3.34** *Mosaic Bottle* Mary Kinney. Scraps of stained glass in related blue and green tones adhered with black metal paste.

Metal pastes are sold in tubes and in pint or quart cans and are available in black, silver, and bronze tones. These colors may be "antiqued" with thin glazes of acrylic or oil colors, which are brushed over the dried paste, then partially wiped away with a soft cloth.

Brand names include "Sculp-Metal" and "Model Metal." Metal pastes are comparatively expensive setting materials and are recommended for small-scale designs unless the budget is unlimited.

The base, or support, for a mosaic design should be selected very carefully. Your enthusiasm for mosaics may be somewhat dulled if initial projects warp or literally fall apart because the bases or supports have been inadequate or poorly prepared.

Almost any rigid, durable surface can be treated with mosaics if it is properly prepared before mosaic materials are applied and if it can serve the intended function of the completed design or project.

In selecting a base or support, consider the nature of the materials to be adhered, the adhesive or setting bed necessary, the use of the design and where it will be installed.

Lightweight or semi-permanent materials (paper, seeds, cardboard, etc.) may be adhered to heavy cardboard that has been sealed on both sides with shellac or plastic spray to prevent warpage. If a frame is desired, attach it before mosaic materials are applied and reinforce the back with a second piece of cardboard for greater strength and to lessen the danger of warping. During the work period, protect the frame from adhesive by covering it with masking tape or paper strips secured with tape.

Heavier, more permanent mosaic materials such as tiles, stained glass, wood, and most "found" materials require a heavier base such as plywood, Masonite, sheet plastics, or a setting bed of cement or mortar. (See "Adhesives and Setting Materials.")

### PLYWOOD

Readily obtainable and comparatively inexpensive, plywood is probably the most widely used base for mosaics. It is available at lumber, hardware, and building supply stores and is most economical when purchased in standard size, 4' by 8' sheets. (Scraps may be obtained at little or no cost.) Plywood "seconds" are less expensive and make excellent supports for panels and tabletops. Plyscord, an unfinished grade of plywood, should also be considered: it is rough on both sides and is less expensive than plywood. Reinforce large Plyscord panels with diagonal braces on the back.

Exterior-grade plywood, containing waterproofing materials, should be purchased if the finished work is to be installed out-of-doors. Regular plywood should not be used outside where it will be exposed to the weather.

Plywood is available in various thicknesses; choose the thickness appropriate for the size and function of the mosaic design. Small panels, up to three square feet, may be made on ¼- or ⅜-inch

plywood. Panels exceeding two square feet may require cross-bracing on the back of the frame to insure rigidity. Larger panels and tabletops require ¾-inch plywood and pieces designed to support considerable weight (benches, garden furniture) require 1-inch thickness.

## PRESSED BOARDS

*Masonite*, like plywood, is available in various thicknesses and some types are more rigid than others. The size of the design should be a guide to the appropriate thickness: larger designs require thicker backing. One-quarter-inch rigid Masonite is adequate for designs up to six square feet.

*Soft-core boards* include pressed boards such as Homosote and Celotex. Beginners will find them adequate for smaller panels not

**Figure 3.35** *The Cape II* by the author. Pebbles set in modeling paste on plywood. Dark polished florist's pebbles provide dark accents in a design of beach pebbles.

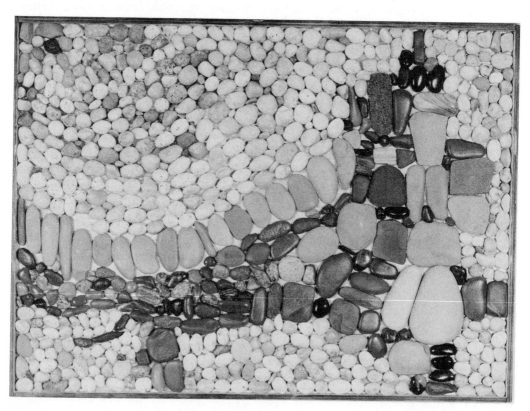

**Figure 3.36** *Patio Table* by the author. The recessed top of the
keg was evenly spread with acrylic modeling paste colored with
burnt umber acrylic color. Flat beach stones and polished florist's
pebbles were pushed into the wet paste. The keg was finished with
walnut oil stain.

exceeding two to three square feet; larger panels require reinforcing.
Seal on both sides to lessen warpage.

*Composition boards* are stronger than soft-core boards and
generally more warp-resistant. "Novoply" is especially recommended
by many professional mosaicists.

### GLASS AND PLASTICS

Tesserae of stained glass and transparent plastics are used most
effectively on transparent or translucent backings which permit the
passage of light. Double-strength glass or plate glass makes excellent
backings, especially for larger panels. Ordinary window glass may be

used for small panels, however, and is more readily available. Opalescent or white glass may be used and gives a softer, diffused light. Mirrors provide an effective backing for stained glass. (Use an adhesive that dries clear to obtain maximum light reflection.)

Plastic panels such as Lucite, Styrene, or Plexiglas can be used effectively and do not shatter or break as readily as glass.

To find the most effective adhesive, experiment with clear-drying glues such as the casein and polyvinyl types; some are made especially for plastic. Epoxy cements, in twin-tube packs, are very reliable. Read labels carefully!

Before adhering mosaic materials to a glass or plastic base, consider how the finished design will be displayed. If the design is to be suspended, a hole can be drilled in the base for a chain or wire hanger; if the design is to be framed, leave a margin free of adhesive and tesserae so that the panel can be slid into the grooves of the frame. If the panel is to be lighted from the back, a deep frame enclosing light tubes should be built.

## OTHER SUPPORTS

Hollow-core doors and unfinished furniture provide excellent supports for mosaics. Manufacturer's "seconds" or rejects, if structurally sound, are entirely satisfactory; small surface flaws can be covered with mosaics. Choose simple, well-designed pieces of furniture.

Supports need not be limited to flat surfaces: drain pipes, stones, clay flower pots, cement planters, and trays or bowls of metal or wood lend themselves to mosaics. Mosaics may be applied over sculptural forms if a sturdy armature is constructed from heavy wire or metal hardware cloth. Scrap or discarded items may be used if the basic shape of the article is good and if the surface is rigid and substantial enough to support the weight of the adhesive and mosaic materials.

Use a cement or mastic type adhesive to set mosaic materials on curved or vertical surfaces; use heavy-duty epoxy glues to join heavy objects such as stones or drain tile. *When joining "unlike" materials, use the adhesive recommended for the nonporous material involved.*

## METALS

Whether new or old, metal surfaces should be thoroughly cleaned to insure proper adhesion. Old surfaces should be free of previous applications of paints or enamels and rust should be removed.

**Figure 3.37** (Detail) *Mosaic Cross* Reinhold P. Marxhausen.
Nails on wood. Nails with polished heads are massed to create the
figure on the cross. The square shape is metal.

Use adhesives recommended for metals such as Ply-Bond or Bond
Master. *Do not use magnesite cement on nongalvanized metal
surfaces.*

## PREPARATION OF BASES AND SUPPORTS

Before mosaic materials are adhered, seal both sides of the panel
with a waterproof sealer (shellac or silicone sealer). This lessens the
danger of warpage and also prevents the mositure in the adhesive or

**Figure 3.38** *Sir George* Chris Lemon. Cut and broken glass set and glued into spaces formed by bent and soldered ½-inch galvanized stripping. Round shapes are marbles. 24″ h. Photo courtesy the artist.

mastic from being absorbed by the porous surface of the panel. If moisture in the adhesive is quickly absorbed, bonding will not occur and the adhesive, along with materials embedded in it, will crack and fall off the panel.

Hardware necessary for the hanging or permanent installation of the mosaic should be attached to the base before the adhesive and mosaic materials are applied, otherwise it may be necessary to drill into the finished mosaic bed to attach fasteners or bolts.

Use heavy-duty hangers (from plate glass or hardware stores) to hang lightweight, portable panels. If the panel is to be fixed in place, use a fastener suited to the construction of the wall: toggle bolts should be used for plaster walls while masonry or concrete walls require expansion bolts. Bolts are available at hardware stores. Drill holes for bolts before tesserae are adhered to the panel. After the panel is bolted into place, adhere tesserae to conceal heads of bolts.

When using mortar or an adhesive such as magnesite cement,

fasten galvanized wire screen or hardware cloth to the surface of the panel with carpet tacks or staples. Cut the screen so that it is one inch smaller than the panel on either side. The mesh will reinforce the cement and insure a better bond. If screen is not used, brush glue or a cement bonding liquid over the surface of the panel before the cement is applied. This step is not necessary when materials are adhered with casein or polyvinyl glues, since these will adhere well on smooth surfaces such as plywood.

## GROUTING, FINISHING, AND FRAMING

Grouting is the technique used in filling the small spaces between mosaic tesserae with a cement or other substance after the setting is completed. The filling material, regardless of its composition, is referred to as grout.

Grouting is necessary for smooth functional surfaces such as tables, countertops, ashtrays, bowls, and trays. If the design is to be used or installed outdoors, grouting will protect it from the weather. This is especially important if porous, ceramic tiles have been used in the design. Silicone sealer will further seal the mosaic surface and protect it from the elements. Renew the sealer periodically. After functional demands have been met, grouting is a matter of choice left to the artist. Many artists do not grout their designs, preferring the unique textural quality created by the open spaces between the tesserae. Others consider grouting an integral part of their designs and utilize grout lines to create movement and pattern on the mosaic surface.

Grouting is impractical and undesirable in designs incorporating a variety of materials of varying thicknesses: a mosaic combining unlike materials such as chunks of glass, glass tiles, and metal shapes is usually set in mastic or a cement-type adhesive bed, which works its way up slightly between the materials. The degree to which the setting bed is allowed to show can be controlled by the artist; colored cements can be quite attractive, creating a textural interest quite their own.

Grout may be purchased at art supply and hardware stores in small or large quantities. It may be left white, or it may be colored with dry colors that are available where grout is sold. If white grout is too distracting, tint it with a color that is neutral or related to a color used in the mosaic design.

In preparing grout, gradually add the dry ingredients to water until the consistency is that of a thin batter. Spread the grout over the mosaic surface and work it into the crevices by hand or with a rubber

spatula or an old brush. (If worked in by hand, use a rubber glove to avoid cuts from sharp-edged tiles.) Continue working until all open spaces are filled, removing excess grout with spatula or soft rags. Try to clean tile surfaces without removing grout from crevices; this will make the final cleaning of the surface much easier.

After several hours, wet the grouted surface again so that the grout will not set too quickly. If grout sets too quickly it becomes brittle and is apt to crack and fall out. When the grout has set, but is not completely dried, clean the surface with soft, wet cloths. Use steel wool, spoons, and tweezers to remove stubborn bits of grout. Professional mosaicists clean designs with full-strength muriatic (hydrochloric) acid to bring out the true beauty and sparkle of tile, particularly smalti. This procedure is not really necessary for the beginner who is apt to be working with less demanding and less expensive materials. *The handling of acids presents safety problems best left to professionals.*

If grout is not purchased, it may be made by combining one part hydrated lime, eight parts sand, and two parts Portland cement. Like commercially prepared grout, this mix may be colored with dry cement colors. A small quantity of white glue may be added to create a stronger, less porous grout.

STAINED GLASS PUTTY. Special black putty is manufactured for use with stained glass and may be purchased from craft supply companies or from stained glass studios. When a design of stained glass is not set in a resin or mortar base, putty may be worked into crevices, by hand, to strengthen the design and to provide contrast.

As a substitute for putty, you can use metal pastes for designs containing larger shapes of glass: those sold in tubes are easiest to use and are available in gray, black, and metallic tones. Simply squeeze the paste from the tube, guiding it along the open spaces, using toothpicks or nails to push the paste into corners and narrow crevices.

PRESSURE-SENSITIVE LEAD TAPE. This simulates lead came, and is available from the 3M Co. but its use is limited to straight-line applications in designs involving comparatively large pieces of glass.

## FINISHING

Because of their inherent beauty, mosaic materials require no "finishing" other than a cleaning or polishing that serves to enhance the natural characteristics of the material or to protect it. Exceptions are designs utilizing a variety of materials where a finish such as spray

paints may be used to integrate, or unify, the various elements of the design.

CERAMIC TILE. Apply paste wax sparingly and buff with a soft cloth. If installed outdoors, brush on waterproofing solution several times a year. Seal work surfaces (tables, countertops) with silicone sealer.

PEBBLES, STONES. Wipe with a soft cloth that has been dampened with liquid nonyellowing floor wax. Buff with soft cloth. Avoid the use of high-gloss sprays, shellac, etc. Rubbing with an oiled cloth will deepen natural colors without imparting a gloss.

COMBINED MATERIALS. Apply matte-finish acrylic medium with a soft brush. This will seal and protect surfaces without adding an objectionable gloss to the entire surface. It may be desirable to leave many combined materials "as is."

WOOD. Apply a good-quality furniture wax with cloth or brush; polish with a soft cloth. Use a toothbrush, or other small brush, to get into crevices and small areas. Spray driftwood with a matte-finish sealer or brush on matte-finish acrylic medium.

**Figure 3.39** *Mosaic Sculpture* Oak and brass. 18″. Reinhold Marxhausen. Lutheran High School Library, Detroit, Michigan. Scrap metal shapes cemented to wood.

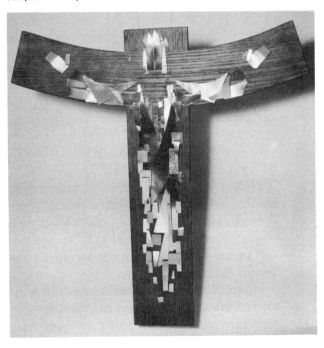

If the mosaic design is made up of many different types of wood, a wood stain may serve to unify the design without obscuring the natural grains of the woods. Spray finishes may be used if an even application of color is desired. Avoid the use of high-gloss finishes that tend to detract from the natural beauty of wood.

METALS. Clean with metal polish and seal or, if color is desired, use a metallic spray finish. Use the spray finish to enhance rather than to obscure the metallic surfaces. Apply sparingly, wiping away excess.

TONING SOLUTION. To tone down the color in a tile mosaic, brush on an oil stain made by adding oil paint (sienna, umber, gray, or combinations) to turpentine. After the stain has set for a few minutes, wipe away the excess with a soft cloth. This stain may also be used to tone a grout that contrasts too sharply with tesserae.

## FRAMING

Most mosaic designs, particularly wall panels, seem to function most effectively when left unframed. Elaborate frames with fussy grooves or beading vie for attention and are distracting. A frame or molding may be required for functional pieces such as countertops, tables, and for panels with edges that are unattractive. In the latter instance, the finishing strip or molding should be wide enough to cover the combined depth of the backing, adhesive, and the projections of the tesserae.

The most widely used framing materials are wood strips, in ⅛- or ¼-inch thicknesses, and metal edging. Furniture woods, such as walnut and mahogany, make handsome finishes but inexpensive pine can also be used effectively if properly finished. Oil or wax finishes are recommended for finer woods; flat, satin-finish enamels are recommended for pine. The top edges of the strips may be enhanced with gold or silver metallic finishes. Wood stripping may be attached with glue or nails.

Metal edgings are available in brass or aluminum and in a variety of widths. These are attached with tacks or screws that are inserted through predrilled holes in the metal. Select a flexible edging if a curved edge is to be covered. After it is attached, polish and lacquer the edging to maintain its appearance (unless it has been lacquered by the manufacturer).

When mosaic designs are made with polyester or epoxy resins, the form surrounding the tesserae, and into which the resin is poured, may serve as a frame. The form may be made from narrow wood

strips or discarded materials. Wood hoops may be used if the depth of the hoop will contain the resin and the materials embedded in it. If epoxy resin is used, the frame does not need to be attached by glue or nails, since the resin will adhere to the frame and bond it as the tesserae are bonded. Clean and finish the "discard" frame before pouring the resin. Cover exposed surfaces of the frame with masking tape to protect them from accidental spills of resin. Do not attempt to remove the tape until after the resin has set; once poured, the resin and tesserae should not be disturbed until the setting action is completed.

Polyester resins may shrink and pull away from frames, particularly where the frame has been painted, waxed, or oiled. If this happens, reattach the frame with epoxy cement or plastic glue. Experiment with the resin to see if treated wood can be adhered, since all resins do not react in the same manner.

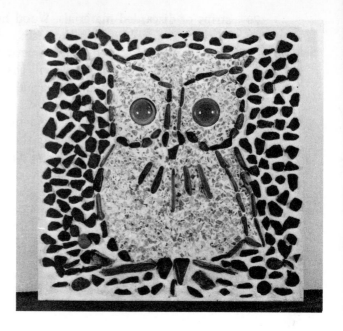

# 4 Methods of Working

The two basic methods of working with mosaic materials are the direct method and the indirect method. Since each method has advantages that serve different purposes, the method chosen should be determined by the nature of the design and whether it is to be decorative or functional.

## THE DIRECT METHOD

In the direct method, mosaic tesserae are set individually, by hand, into the adhesive or setting bed, which has been spread or applied to the base or support. This individual setting makes possible the greatest utilization of the uneven surfaces of fine mosaic tesserae, such as smalti, and the control of light reflection by tilting the tesserae at varying angles. This uneven surface quality produces a

(a)

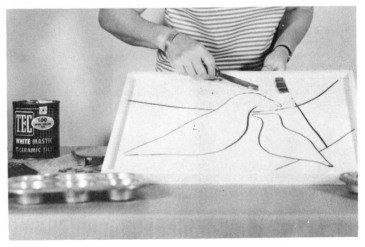

(b)

**Figure 4.1** *Demonstration*: Direct method, tile mastic with Venetian glass tile on plywood. (a) In the felt-pen sketch for *Sea Birds*, shapes and values are simple and clearly defined. Short strokes of the pen indicate the directions in which the tiles will be laid. Colors are planned: the darkest areas, black; medium tones, blue-greens; the lightest areas, white.

(b) The sketch is transferred to the white-painted plywood base, which has been framed with narrow wood strips. Because the panel is not to be grouted, the cement is spread thinly so it will not rise up between the tiles when they are pressed into place. A few dark tiles have been set close to the outline and additional mastic is being spread with a flexible knife. Tiles are precut and sorted according to color and shape in muffin tins.

81

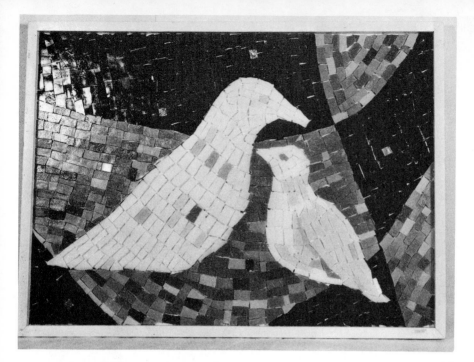

**Figure 4.1** (*cont.*)  (c) *Sea Birds*  by the author. 21″ x 15″. The
finished panel follows the plan of the original sketch except for
slight changes in direction of laying the tile (note upper right) which
provided some needed contrast in texture. Variety is achieved within
shapes by varying the colors slightly or by adding a contrasting value
(note bodies of birds and the foreground). Eyes are bright orange.
Bits of metallic smalti provide glittering highlights in the darkest
areas.

mosaic design that is more vibrant, more "alive," and one that
changes as the angle of reflection is changed.

Used from earliest times, the direct method is the most likely to
be used and favored by beginners because of its obvious basic
advantages: the tesserae are placed right side up; this permits the
artist to see, from the beginning, what he is doing. Mosaic tesserae of
varying thicknesses and weights may be used, such as tiles, chunk
glass, and pebbles, which can create greater textural interest and
vitality. Areas of flat, shallow materials may be contrasted with areas
that project or stand out from the surface. The direct method is,
basically, the simplest method, and the one most effective for
creating decorative surfaces (wall panels, murals, sculptural designs)
for which spontaneity and vitality are the prime considerations.

Because the direct method makes possible greater variations in the
use of materials and in ways of working, the choices of materials and
adhesives depend on the demands of the design and on the artist's
**82**  personal style or manner of working.

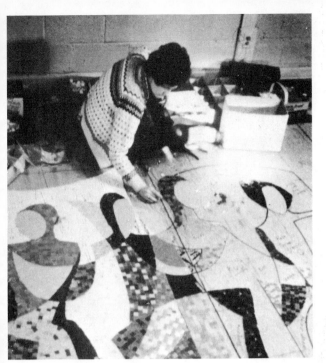

(a)

**Figure 4.2** *Mosaic Mural* Ceramic tile. Betty Wells. Designed by the direct method on four plywood panels, for the Taylor Manor Hospital, Baltimore, Maryland. (a) The design has been enlarged and drawn directly on plywood panels with a felt-tip pen. Color notations are made in each area of the design. Tiles are set individually directly into spread mastic.

(b) The four panels are installed upright with unfinished joints exposed but fastened securely.

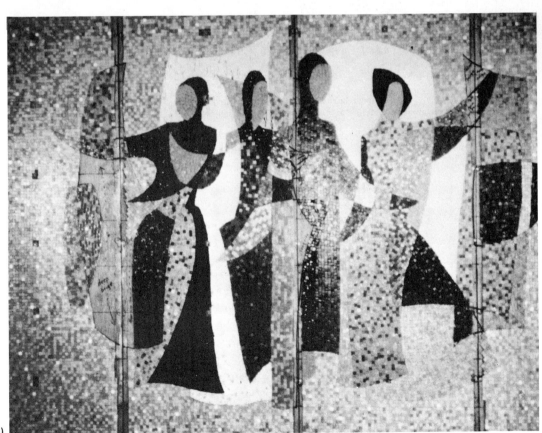

(b)

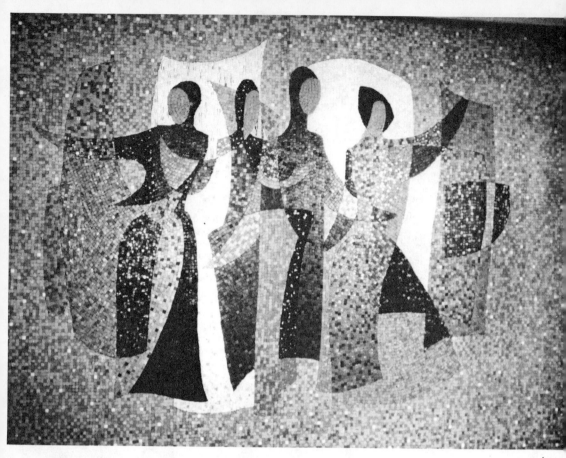

**Figure 4.2** *(cont.)*    (c) Tiles have been applied over the joints so
that the design is uninterrupted. Note how shapes have been planned
to overlap the joints.

## *MASTICS AND GLUES*

*Tesserae of uniform thickness*, such as glass or ceramic tile, may be
adhered directly to the base or support with tile mastic, casein glue,
polyvinyl glue, or other "household" cements. These adhesives will
adhere well to a flat surface and the base or support requires no
special preparation. Beginners will find these adhesives easier to
handle than magnesite or cement. Because these adhesives are applied
in relatively thin layers, tiles or tesserae cannot be tipped or angled as
effectively as in a thicker setting bed such as magnesite, acrylic paste,
or mortar.

Finished designs may be grouted or left ungrouted. Utilitarian
surfaces such as tabletops and counters are more easily kept clean if
they are grouted. Decorative pieces such as wall panels do not require
grouting.

**Figure 4.3** *Demonstration:* Stained glass on a plastic base.

(a) A scrap of clear sheet plastic approximately ¼-inch thick was prepared for a base. Edges were covered with masking tape to reserve margins that would allow the panel to be slid into a frame or drilled for the attachment of a hanger. Random cuts of stained glass in a variety of colors were adhered with a clear-drying white glue. Narrow crevices were left between the shapes of glass.

(b) Crevices between the glass are filled with a black metal paste squeezed from a tube. A nail is used here to push the threads of paste into narrow spaces. The black paste provides contrast for the brilliant colors and seals the crevices that would allow distracting "white" light to show through. The paste dries quickly and is easier to manipulate than might be imagined.

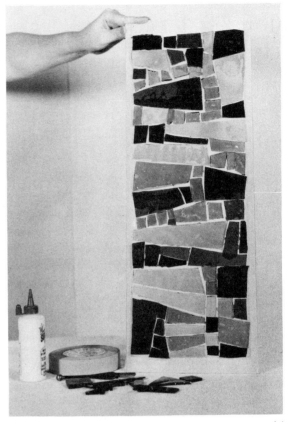

(a)

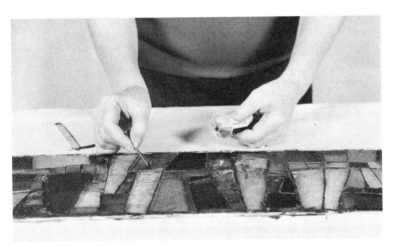

(b)

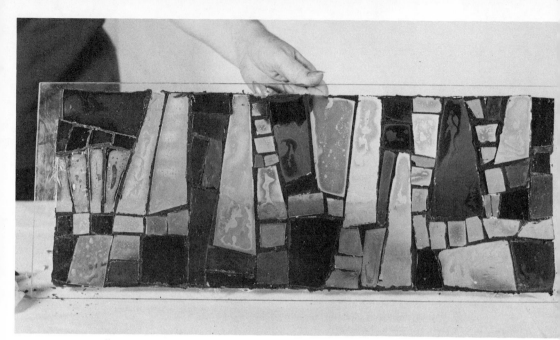

**Figure 4.3** (*cont.*)    (c) The masking tape is stripped away and the panel is now ready for framing or hanging by wire or fine chain. It might be mounted in a pre-existing window frame.

(c)

**Figure 4.4**    *Off Stonington, Maine*    Unfinished, by the author. Pebbles in modeling paste on plywood. Modeling paste was colored an earth-tone to provide a setting bed for the darker pebbles. The unfinished areas at the top of the panel show the white-painted plywood base. Liquid floor wax was rubbed lightly over the darkest pebbles to heighten colors.

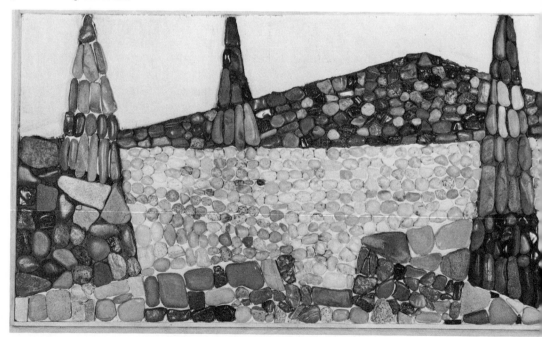

*Tesserae of irregular shape and thickness*, such as stones, crystals, and wood, are set most effectively in a thicker setting bed that permits tipping or angling of materials and that provides a "cushion" of adhesive under irregular surfaces.

These thicker setting beds may consist of acrylic paste, magnesite cement, or mortar. The choice should depend on the tesserae used, the design, and the function of the finished project.

## ACRYLIC PASTE

When acrylic paste is used, the base requires no special preparation; simply spread the paste about ¼ inch thick over a small area of the design and set tesserae, as in working with tile mastic. Press tesserae firmly into the paste, tilting individual pieces to create varying patterns of reflections. At the end of the work period, scrape away unused areas of paste since it is very difficult to remove when dry.

## MAGNESITE CEMENT

In constructing a mosaic with magnesite cement, transfer the design to the base or support, making sure that lines and shapes are clearly defined. Attach screen or hardware cloth, as described in Chapter 3, using tacks or strong wire staples. Press the screen firmly against the base and fasten it from the center, outward, to prevent ripples in the screen; these would interfere with the application of cement.

Mix a small amount of magnesite—about one pint—and spread it about ¼ inch thick on a small area of the design. The proper thickness of the cement layer is determined by the size of the tesserae to be set; larger tesserae require a thicker setting bed. Try to keep a fairly uniform setting bed, even when sizes of tesserae vary, embedding larger tesserae more deeply than smaller tesserae.

Mix only the amount of magnesite that can be used within a short time—perhaps a half-hour—until experimentation provides some guidelines. If magnesite sets too quickly, add a bit of water to the chloride solution.

If a colored cement is desired, add the dry color to the dry cement and blend thoroughly before adding the chloride solution. To color small areas, sprinkle a bit of dry color over the wet cement that has been spread and blend it with a spatula or tongue depressor.

At the end of a work period, scrape leftover areas of cement from the base, removing it neatly from the edges of tesserae. If the cement

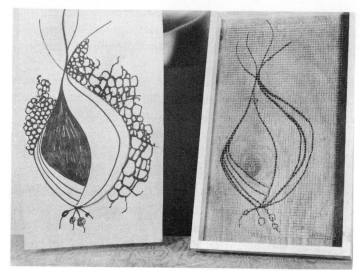

(a)

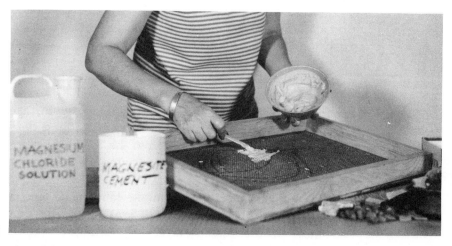

(b)

**Figure 4.5** *Demonstration:* Direct method, magnesite cement on plywood.

(a) The sketch (left) is first drawn with felt pen on kraft paper with some indication of values, textures, and directions for setting tile. On the right, the sketch is transferred to a framed plywood panel which has been covered with hardware cloth. Stapled in place, the hardware cloth provides an "anchor" for the magnesite bed, assuring better adhesion. The hardware cloth reinforcement is not essential for a panel as small as this one (14" x 22") but should be used for panels that exceed four square feet.

(b) Starting to set the tile. Magnesite cement is mixed to a smooth, paste-like consistency and worked down through the reinforcing hardware cloth. In this illustration, a few tiles have been set and the cement is being spread into a small area for additional setting. Because the cement hardens fairly quickly, spread only a small area at a time and precut tiles so that setting proceeds without long delays.

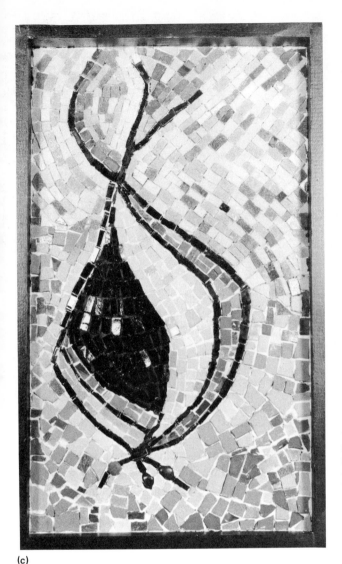

Figure 4.5 (*cont.*)　(c) *Spring Seed*
The completed panel. 14" x 22". Tiles
used include scrap floor tile (lower
section), Venetian glass tile and color
accents of smalti. Colors are largely
warm tones of beige, gold with bits of
orange smalti; darkest tones are black
Venetian tile set in magnesite, made
black with dry cement color. The pine
frame was finished with a satin finish
black enamel.

(c)

is left on the base to dry, it forms an extremely hard and uneven
surface that must be chipped away before work can resume. When
work is resumed on the design, wet the finished, dry surface adjacent
to the areas that are about to be done. This wetting is important
because the dried cement tends to absorb moisture from freshly
applied wet cement, preventing the proper bonding to the base and
to the tesserae.

Because magnesite exerts a corrosive action on metal, clean and
wash all tools very carefully at the end of the work period. Rubber
or plastic spatulas may be used and are more flexible than metal
tools. Handy, easy-to-clean mixing containers may be fashioned from

**Figure 4.6** *The Wave* by the author. 15″ x 32″. Pebbles, set by the direct method, in magnesite. The base is plywood. Bits of tile, coral, shell, and stained glass nuggets provide contrasts in textures. The beige tone of the magnesite is darkened slightly by an umber acrylic glaze that was brushed over the entire surface, then wiped away. The surface was lightly waxed to enhance the colors, which are largely earth-toned.

plastic bleach jugs: simply cut off the top portion to the desired height.

Hands should be washed frequently to avoid irritation that may occur if the cement is handled extensively. Use plastic scoops to transfer dry cement from the bag to the mixing containers.

If the cement is accidentally dropped or spilled onto the surface of the tesserae, remove it immediately with a soft cloth or damp sponge. When dry, the cement is extremely hard and must be gouged away with a sharp, pointed tool.

*Cement mortar* provides an ideal setting bed for constructing small mosaic slabs designed for outdoor installation. Although this technique is not often used in the classroom, it may be considered for the construction of special group projects to be installed in a courtyard or on a patio wall.

In this technique the mortar becomes both base and adhesive, eliminating the need for constructing a wood base. From scrap boards, construct a form—a bottomless box—that is at least three inches deep. All four corners of the form may be loosely nailed or, for easy removal,

hinge one corner and fasten another with a hook-type latch. (See page 47.)

Place the form on a work surface covered with waxed paper to prevent the mortar from adhering to the surface. (Wide, waxed freezer wrap is excellent for this purpose.)

Mix the mortar for the first pouring, following directions for ready-mixes or according to formulae given in Chapter 3. Pour the mix into the form to a depth that is approximately half the depth planned for the completed slab. Tap the sides of the form to level the mix and to force air bubbles to the surface. To reinforce the slab, cut metal hardware cloth about one inch smaller than the base, and place it at midpoint in the form; press the mesh into the wet mortar, making sure that it does not touch the edges of the form. (Metal rods may be substituted for hardware cloth.)

**Figure 4.7** *Demonstration:* Direct method with mortar.
(a) A bottomless frame is set on a level surface (plywood) which has been covered with heavy waxed paper. Nails are driven a short distance into the base to keep the frame from accidentally sliding out of position. The inside of the frame is waxed for easy removal. A commercially prepared mortar, mixed rather thickly, is poured to a depth of one inch. Reinforcing wire, cut slightly smaller than the panel, is then pushed into the wet mortar. A second layer of mortar is poured to a depth of one inch and leveled. Tiles are then pressed firmly into place, following a design traced into the mortar with a sharp stick. The panel as shown is ready to be set aside to dry.

(a)

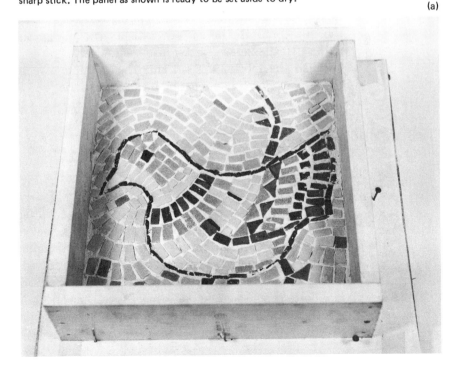

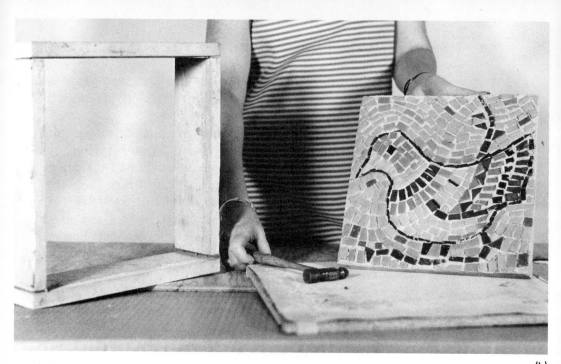

**Figure 4.7** (*cont.*)     (b) The sides of the frame are knocked away
to free the now solid panel. After being cleaned of stray bits of
mortar, tiles may be waxed. Such a panel could be installed outside
in a patio or garden wall.

Mix the setting bed to the consistency of very thick batter and
pour over the hardware cloth, tapping the sides of the form to level
the mix. Smooth the surface with a trowel or spatula and proceed
with setting tesserae directly into the mortar.

When the mortar has set and dried completely, knock the wood
form away with a hammer and clean the mosaic.

## THE INDIRECT METHOD

### MASTICS AND MORTARS

In the indirect or reverse method, tiles are pasted face down on the
design, which has been traced in reverse on a heavy paper, such as
kraft paper. When all the tiles are adhered, the paper—with the tiles
attached—is lowered, paper side up, onto a prepared setting bed of
mastic or mortar. The paper is then rolled or pressed to embed the
mosaic tesserae securely and evenly into the setting bed. Permit the
mortar or mastic to harden somewhat before removing the paper
backing. To remove the paper, wet it thoroughly with a wet cloth or

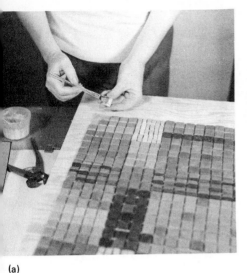

(a)

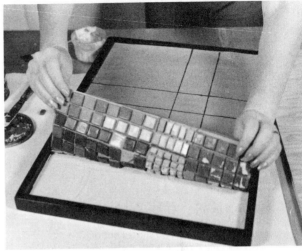

(b)

**Figure 4.8** *Demonstration:* Indirect method. A tray designed with glass tiles set in mastic on a Masonite base.
(a) A design drawn on kraft paper (left) is transferred in reverse to a second sheet of kraft paper to which tiles are pasted face down. A water-soluble paste is used. A piece of plywood is used as a working surface so that the paper with tiles attached may be moved out of the way to dry. (b) The paper sheet with tiles attached is lowered paper side up into the bottom of the tray, which has been spread with a thin layer of tiles mastic. (If a few tiles fall from the paper sheet, simply repaste or reset them before the design is grouted.) Firmly press the entire surface, pushing the tiles into the mastic. A rubber brayer is handy for this purpose when a large panel is designed. (c) After the mastic has set for several hours, rub the surface of the paper with a wet cloth or sponge so that the paper can be easily peeled away from the tiles.

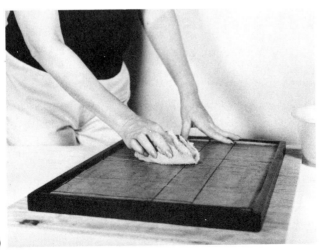

(c)

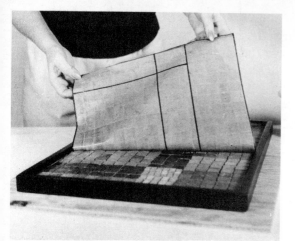

(d)

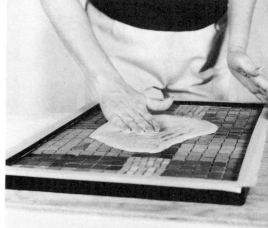

(e)

**Figure 4.8** (*cont.*) (d) The wet paper is lifted from the tile revealing a flat, even surface. If a few tiles have shifted out of place, reset them with a bit of mastic before proceeding with grouting.
(e) Grout mixed to a thick, creamy consistency is poured onto the surface of the tile, and here, worked in by hand. (A rubber spatula may be used.) After the grout has been carefully worked into all spaces between the tiles, the surface should be wiped clean, then buffed with a soft cloth or crumpled newspaper. Masking tape protects the edges of the tray from the grout. (f) Finished tray, shown here turned on edge, is now ready for use. Liquid wax or silicone sealer might be applied for a more durable, easy-to-clean surface. Colors are largely related tones of gold, orange, and red with bands of dark blue. 21" x 15".

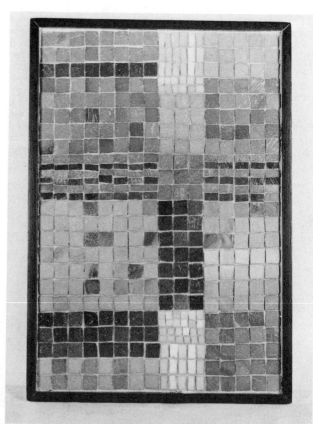

(f)

sponge, then slowly peel it up and away from the tesserae. The mosaic surface revealed is level and flat. If the mastic or mortar is not too hard, correct the positions of tiles that have been dislodged.

The obvious advantage of the indirect method is that it achieves the flat, level surfaces desirable for work surfaces or other utilitarian objects such as countertops, tables, floors, and benches. Moreover, mistakes in design are easily corrected on the paper before it is lowered into mastic or mortar; simply moisten the paste and remove the offending tile. If the setting bed is mortar, tiles of uneven thickness may be used because the rolling of the paper surface "equalizes" the tile; thicker tiles are simply more deeply embedded than others. (If tiles are uneven in thickness, the mortar must be thick enough to accommodate the thickest tile.)

It is important that the paper on which the design has been reversed, and to which the tile is to be pasted, is the same size as the base to which it will be transferred. The paste used to adhere the tile to the paper should be strong enough to hold tiles in place but one that is easily soluble in water. A flour and water paste made from one part flour and eight parts water has been found satisfactory for this purpose. Boil the mixture for about five minutes and strain. Very strong glues are difficult to remove and cause the paper to shrink considerably, making accurate placement difficult.

The indirect method is used extensively in designing mosaics that cover comparatively large surfaces such as murals, walls, or other architectural applications. In such instances, the design, or cartoon, is drawn on heavy nonshrinking paper and then cut into sections. Skilled workers, under the supervision of the artist, cut and adhere tesserae according to the artist's detailed plan. The completed work is then carefully marked and shipped to the site where it is to be installed. On the site, the mosaic is installed in sections by skilled tilesetters whose work is supervised by the artist. Any necessary adjustments or refinements are made on the site by the artist.

With the development of new adhesives and improved construction materials, particularly panels that serve as supports for mosaics, there is less real need for the old techniques. In many contemporary studios, the mosaic design is fixed in place on prepared panels that are ready for immediate installation at the site.

The method of working in mosaics must be consistent with the intended function of the completed design and appropriate for the materials to be used. When these practical demands have been met, the method chosen by the artist depends on his personal interpretation of mosaic art and his individual style of working.

Improved adhesives, particularly the epoxies, have made possible many new techniques in mosaic art. In epoxies, artists discovered a bonding agent that is strong, comparatively lightweight, and impervious to the corrosive effects of weather and atmosphere. Sparkling mosaic walls of stained glass are cast in epoxy eliminating the need for traditional lead cames or heavy cement supports. Glass mosaics designed with thick slabs of glass, or dalles, faceted to reflect light, are replacing the more traditional stained glass windows in many churches. Interior designers and architects have incorporated this "new" mosaic art in their designs and plans for homes, industry, schools, and public buildings.

While more sophisticated techniques that require considerable technical knowledge and skills are not practical in the average home or classroom, beginners may experiment with epoxy resins and cement in smaller, less ambitious projects. Suggestions for these experimental approaches follow.

SAND CASTING. Sand casting as a mosaic technique may involve the use of casting plaster or mortar. The technique is essentially the same, whatever material is used: a level bed of sand is arranged in a box or wood frame, the inside of which has been rubbed with a separating film of wax, grease, or oil. (This separating film prevents the plaster or mortar from sticking to the sides of the box or frame, which will be removed when the mosaic bed has set.) Mosaic materials such as pebbles, tiles, marbles, scraps of glass, or other found materials are pressed firmly into the sand, following a presketched design or a random pattern. Materials that are to project sharply from the surface are pressed more deeply than others.

When the materials have been arranged in a pleasing pattern, plaster or mortar is carefully poured or spooned over the entire surface to a depth that is approximately half that of the completed panel.

Before the first pouring is completely set, place a piece of metal hardware cloth or screen over the plaster or mortar, pushing it into the surface or attaching it with wire staples. This will strengthen the panel and lessen the danger of cracking. Attach a length of wire approximately one-third the distance from the top of the panel to serve as a hanger.

Pour the second layer of plaster or mortar and tap as before to level the surface. Permit the panel to dry for two or three days before ripping away the box or removing the sides of the frame.

Methods of casting in sand are further described in Figure 4.9 (a) through (f).

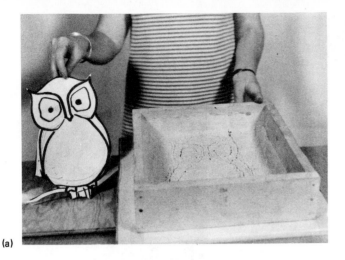

(a)

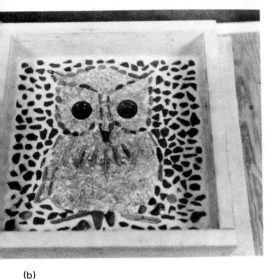

(b)

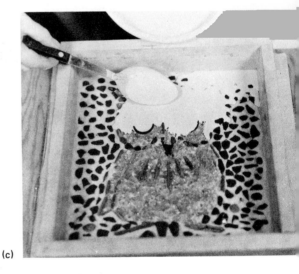

(c)

**Figure 4.9** *Demonstration:* A sand cast mosaic panel.
(a) A bottomless box or frame constructed of 1" x 4" lumber is set
on a flat surface that is covered with heavy waxed paper. The inside
of the frame is rubbed with wax to repel the plaster and to make the
frame easier to remove. Sand is poured into the frame to a depth of
approximately one inch, leveled, and lightly dampened. The design
is transferred to the sand when the cut-paper pattern is traced
around with a stick. (b) Mosaic materials are pressed into the sand.
The background is made of brown florists' pebbles, beach pebbles
define the body of the owl, which is crushed amber glass, the perch
is made of slivers of driftwood, and the big eyes are blue glass bottle
stoppers. (c) Plaster of a creamy consistency is spooned over the
surface to avoid displacing the fine crushed glass. The plaster is
poured to a depth of approximately one inch, then the box is tapped
to level it.

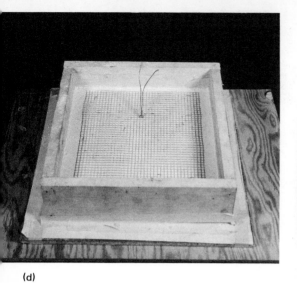

(d)

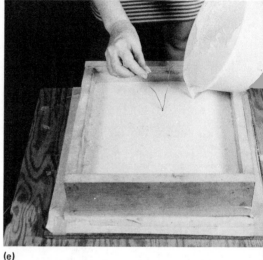

(e)

(f)

**Figure 4.9** (*cont.*)    (d) Before the plaster has completely hardened, wire mesh or hardware cloth is attached with wire staples. (Mesh may be pushed into very wet plaster but is sometimes difficult to position properly.) Note that wire, which will serve as a hanger, has been twisted into the reinforcing wire, cut slightly smaller than the panel. (e) The final layer of plaster is poured to a depth of about one inch. The panel is now ready to be put aside to dry. Permit to dry for at least forty-eight hours, since the panel is comparatively thick. (f) The sides of the frame are knocked away and loose sand is brushed from the surface of the panel.

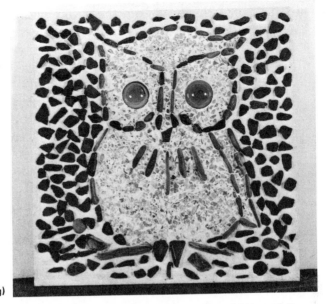

(g)

**Figure 4.9** (*cont.*)  (g) *Blue-eyed Owl*  Completed panel. Some of the dark pebbles have been waxed to heighten the rich brown colors.

Casting is a popular technique for the classroom because materials are generally readily available and quick results are possible. Casting is not recommended for large panels because the plaster or mortar must be poured to a depth of approximately two inches, creating a comparatively heavy panel.

EXPERIMENTAL TECHNIQUES: EPOXY AND POLYESTER RESINS.  The small panel shown on p. 100 is an experiment in casting using plasticene as a base and epoxy resin as a binder. On a sheet of waxed paper, a slab of plasticene was rolled to a thickness of approximately one inch. (Wood strips were placed on each side of the slab, as it was rolled, to keep the depth at a uniform level.) The overall size of the slab was about an inch larger on all sides than the finished, framed panel would be.

A frame, approximately one and one-quarter inches deep, was pressed firmly and deeply into the plasticene to provide a leakproof retaining wall for the resin. After the frame was firmly in place, irregular chunks of stained glass were pressed into the plasticene. Larger chunks were embedded more deeply than smaller, gemlike shapes. When the arrangement was completed, black epoxy resin of a table syrup consistency was poured between the pieces. Because the resin is extremely strong, it was not necessary to pour a deep layer; the hardened epoxy is approximately an eighth of an inch thick in

the panel shown. Before the epoxy was completely hardened and while the surface of the resin was still tacky, finely crushed black glass was sprinkled liberally over the entire design and pressed gently around the edges of the glass shapes. The crushed glass provided a rough, interesting texture, contrasting with the larger glass shapes.

When the resin had completely hardened, the frame was lifted from the plasticene base and the excess crushed glass was shaken from the surface of the panel. The plasticene was pulled and scraped away from the back of the glass until only a thin film remained. Final cleaning of the back was completed with lighter fluid. (Other solvents may be used.) Light now passed, unobstructed, through the glass, which was surrounded by an opaque, black background.

The plasticene was chosen as a base because its oily surface resists epoxy resin and because a thick bed which would permit the embedding of chunk glass was needed. As a practical consideration, plasticene is available in the average art classroom or art supply store.

It was possible to bind the glass and frame in one operation because of the nature of epoxy; it does not shrink away from wood or glass as do some polyester resins sold for craft uses. Although the epoxy resin may seem expensive, it is economical in use because even a thin pour binds more securely than many less expensive adhesives or mortars used in larger amounts.

**Figure 4.10** *Experimental Panel*
Irregular chunks of stained glass in epoxy resin. Plasticine modeling clay is used as a base in which chunks were embedded. The procedures are described in this chapter.

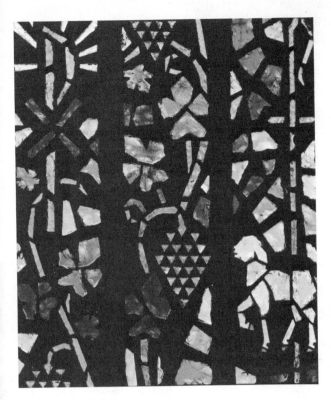

**Figure 4.11** *Glass Mosaic* Arcadia (California) Presbyterian Church. Faceted glass dalles cast in epoxy cement. Although shown here as a single unit, the panels were cut apart and installed as a tall vertical window. Photo courtesy Judson Studios, Los Angeles, California.

Obviously, the experimental method just described is not appropriate for a very large panel, but a series of small panels designed in this manner could be joined to create a larger unit, such as a screen or window panel.

Another experimental method of working with stained glass and epoxy resin is described on pages 102-4. This technique is similar to the one just described in that a retaining wall or frame is needed and a base, or working surface, that will separate from the epoxy resin is necessary. In this instance most of the glass used is sheet glass; this does not require a thick base for embedding. A sheet of acetate taped over white drawing paper was used as a base. Secondly, since the epoxy resin was almost clear in color, it was planned so that light would pass through the entire surface of the panel rather than through selected pieces of glass. Resin was poured between the pieces of glass but, because the thickness of the glass varied, some pieces were either partially or completely embedded in the resin. This variation was not critical since the resin was clear and the covered pieces of glass were not obscured as they would have been in a black, opaque resin.

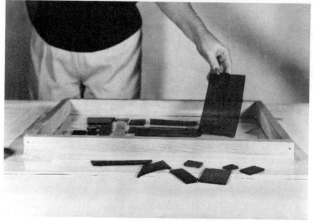

(a)

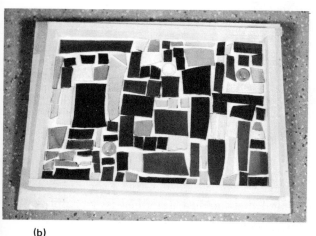

(b)

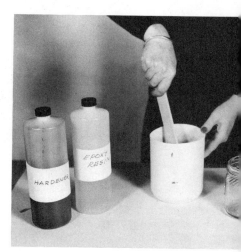

(c)

**Figure 4.12** *Demonstration:* Stained glass and epoxy resin.
(a) In this technique it is important that the working surface be
level and light-colored— so that glass colors are more easily selected—
and covered with a material that will resist the epoxy resin. The base
used here is a piece of plywood covered with white paper; a sheet of
acetate to resist the epoxy is taped over the paper. A narrow wood
frame is placed on top of the acetate and sealed tightly on all sides
with masking tape. It is important that edges be tightly sealed or else
the resin will seep out under the frame. Stained glass is arranged
directly on the acetate. Glass need not be uniform in thickness.
(b) The arrangement of stained glass is now completed. The
domelike shapes are glass factory scrap; remaining pieces are random
cuts of scrap. Although spaces are left between the glass in this
arrangement, it is not necessary to do so, since the resin will be
poured over the entire surface of the panel, not just between the
shapes. (c) The epoxy resin is mixed with the hardener and stirred
thoroughly. *Thorough mixing is essential for proper hardening or
"curing."* The brand used required equal proportions of resin and
hardener; other brands may require different proportions. Since the
resin is almost impossible to remove, use disposable containers and
stirring sticks. The mixing container shown here is a cut-down
bleach bottle; the "measure" a pickle jar—both disposable.

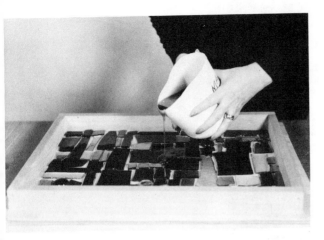

**Figure 4.12** (*cont.*)    (d) The plastic
container is squeezed to form a spout
and the resin is poured evenly, over the
panel. It is not necessary to pour a thick
layer of resin; a paper-thin layer is
extremely strong. If thicker pieces of
glass project above the surface and are not
touched by the resin, no harm is done.
Be sure that the resin fills the spaces
between the glass and that it touches
the frame at all points. The panel should
be left to harden for approximately
twenty-four hours; check manufacturer's
labels for specific curing time required.
(e) After the resin has cured, or
hardened, pull the masking tape away
from the outer edges of the frame and
turn it on edge. The acetate sheet that
separated the resin from the working
surface can now be peeled from the
back of the panel. If there are hardened
spills of resin along the bottom edge of
the frame, they can be trimmed away
with a sharp knife.

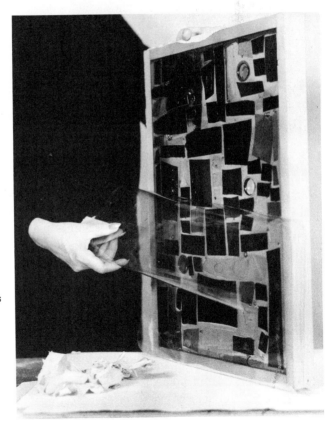

(e)

103

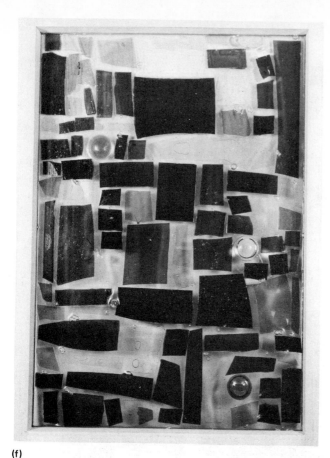

**Figure 4.12** (*cont.*)     (f) *Finished panel*
Small bubbles can be prevented by being
pricked with a pointed tool before the
resin sets. In a design of this type, they
are not particularly objectionable,
appearing almost beadlike.

(f)

*Polyester resins* may be used in very much the same manner as epoxy resins but with some important differences which should be understood before a design is planned. Many of the polyester resins sold for craft purposes do not adhere well to nonporous surfaces; therefore, it is not always possible to use a finished frame that has been oiled, waxed, or stained. The resins also shrink or pull away from metal frames. This shrinkage is not immediately apparent but may occur two or three days after a panel is, in all appearances, completely hardened. The best procedure is to do a test to determine the specific working properties of the resin available for use. If larger, nonporous materials such as chunk glass are to be used, it is best to construct the panel in layers: before arranging mosaic materials on the separating sheet (acetate or Mylar), pour a thin layer of the resin and let it reach the gel stage, then arrange the mosaic materials over it. *Place the materials as accurately as possible since the plastic has a "memory" and mosaic materials, although moved, tend to float back to their original positions.* Work quickly, because curing or hardening proceeds rather rapidly once the gel stage is reached. When all

materials are arranged and the resin has hardened further, pour the final layer of resin. The proper depth of the pour must be gauged by the thickness of the mosaic materials used; thicker materials require a deeper layer. Experimentation provides the best guide; design miniature panels before attempting larger pieces requiring more materials and time.

In working with epoxy or polyester resins, follow the manufacturer's directions meticulously, giving particular attention to the amounts of catalyst, or hardening agent, required. Do not use coloring agents or aggregates other than those recommended because they may interfere with the proper curing or hardening of the resin.

**Figure 4.13** *Stained Glass in Polyester Resin* 17" in diameter, by the author. Two wood rims from a small drum were used to shape and to frame this glass and resin mosaic. The less attractive rim with notches was used as a retaining wall into which the resin was poured; the better rim was reserved for a finished frame.

The notched frame, with notches up, was taped to a sheet of acetate and the outside edges tightly sealed with plasticine (modeling clay). A thick layer of polyester resin was poured into the frame and allowed to stand until the soft gel stage was reached. The pieces of glass were arranged on top of the resin; this was done quickly because the resin hardens fairly rapidly once the gel stage is reached. A final layer of resin was poured, then the panel was left to harden. In (a) the panel has hardened and has shrunk and pulled away from the retaining rim. In (b) the panel is shown after being cemented into the painted, "better" rim.

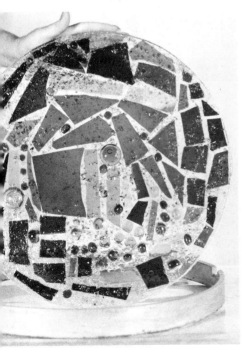

(a)

(b)

Be sure that mosaic materials to be embedded are free of oil, grease, wax, or soil that would prevent proper adhesion.

Experimental uses of polyester resins are shown in Figure 4.13 (a and b).

## LAMINATION AND FUSING

Other experimental techniques include lamination, or constructing the mosaic in layers. In this technique, mosaic materials are adhered to a base or support of heavy glass or transparent plastic. A frame, or retaining wall, is placed around the design and a resin (epoxy or

**Figure 4.14** *Autumn* One of four panels for each of the four lobbies, Park Towne Place, Philadelphia. Mariette Bevington. Stained glass laminated to plate glass, 4' x 7'. Framed in brushed steel with lighting concealed in the frame. Photo courtesy the artist.

polyester) is poured over the entire design until the "tallest" bit of mosaic material is covered. A second piece of glass or plastic, the same size as the base, is gently lowered over all, creating a layered design, or lamination. When the resin has hardened, a solid unit is obtained: the base, the mosaic materials, and the top sheet are bonded by the resin.

In working in this manner, carefully check the properties of the resin; if the retaining wall or frame is *not* to become a part of the finished design, it should be coated on the inside with a separator or parting agent so that it may be easily removed. The parting agent may be a simple coating of wax or paraffin, or a commercially prepared product that is available wherever resins are sold. Again, follow the directions of the manufacturer of the resin since resins vary widely in their working properties and characteristics.

Mosaic tiles manufactured from polyester resins may be cut and adhered in the same manner as ceramic or glass tile. In another technique, the tiles can be fused in an ordinary kitchen oven or small portable broiler, at 350°F. The tiles are arranged on a base of aluminum, Pyrex, or ovenproof ceramic. A cookie sheet, covered with aluminum foil, provides a good base. After placing the arrangement in the oven, check it frequently and remove it when the desired degree of fusing has taken place.

Wall panels, suspended forms, and small pieces of jewelry may be designed in this manner.

Techniques for fusing are described in Figure 4.15 (a) through (c).

**Figure 4.15**   *Demonstration:* A fused mosaic with plastic tiles.
(a) Pieces of tile are cut or broken and placed on a baking sheet covered with aluminum foil. Pyrex containers, aluminum pans, or ceramicware may be used as bases.

(a)

(b)

**Figure 4.15** (*cont.*)　　(b) Panel nearing completion. Note that tiles
are layered in selected areas. (c) Panel being fused in a kitchen-type
oven at 350° F. A small oven broiler (portable) or kiln may be used
safely in the classroom.

(c)

(d)

**Figure 4.15** (*cont.*)    (d) Completed panel made exclusively of plastic tiles fused in a kitchen oven. Glue or cement as well as heat may be used to adhere plastic tile to a base.

**Figure 4.16**    *Hanging Panel*    Dawn Pumphrey. Stained glass fragments fused on a blank of window glass. After firing, the panel was laced into the frame, which is decorated with ceramic beads. Photo courtesy the artist.

**Figure 4.17** *Fused Glass Panel*
Mildred Vanatter. Mounted on painted
hardboard with clear-drying cement.
Photo courtesy the artist.

**Figure 4.18** Quick-drying clear cement
which does not obstruct the passage of
light is used to mount tile on a plastic
base. Note squared guide sheet under the
clear base. Such an aid can be helpful for
beginners.

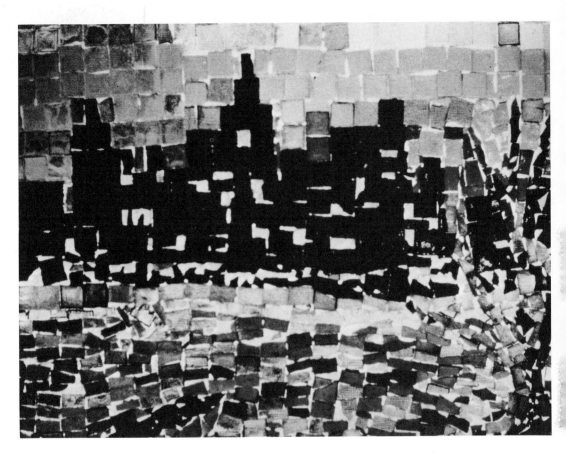

**Figure 4.19** *City Skyline*    Plastic tile mounted on a plastic base.
By an 11-year-old boy. (All photos of plastic tile techniques courtesy
Poly-Dec Co., Bayonne, N.J.)

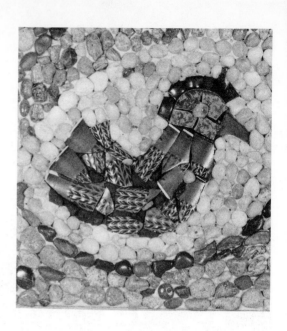

# 5 Mosaics in Art Groups and Classrooms

## COLLECTING MOSAIC MATERIALS

Mosaic activities in the classroom or art groups are not prohibitively expensive when beginners discover that they need not go far in our everyday environment to find materials for creative mosaic designs. Contemporary mosaics incorporate a wide diversity of common, readily available materials in addition to the more traditional or conventional mosaic tiles. Where budget restrictions do not permit purchases of adequate quantities of mosaic tile, mosaic activities should be planned well in advance so that other materials may be collected in sufficient quantities before student work gets under way. Nothing dampens enthusiasm as quickly as a shortage of needed materials!

*Scrap tile* may be obtained at little or no cost from tile contractors or suppliers. Often, "leftover" tiles from construction sites are hauled away to the city dump, a happy hunting ground for the

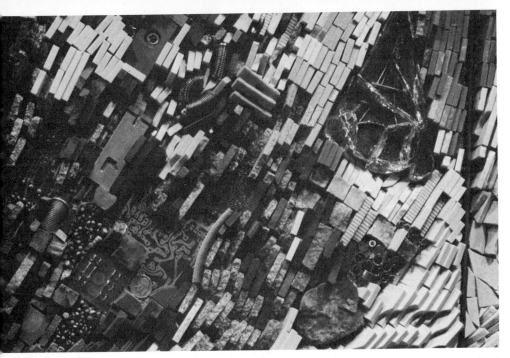

**Figure 5.1** (Detail) *Mosaic Mural* Found materials, Glen Michaels. In addition to a variety of tiles, scrap and "found" materials include springs, metal tubes, printed electrical circuits, pebbles, stones, an assortment of small metal parts, and a coin. Despite the diversity of materials, a unity is achieved by carefully planning grouping and arrangement. Photo courtesy Bulova Watch Co., New York.

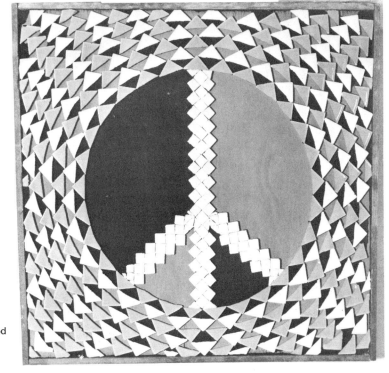

**Figure 5.2** *Peace* Student, Baltimore City Public Schools. The background surrounding the symbol is made entirely of triangular cuts of ceramic tile. Flat areas within the symbol are free of tile and are painted. The support is plywood. Narrow wood strips are used as framing.

designer of mosaics. Scrap tile obtained from these sources provide
quite a variety: there will be shiny ceramic tiles, perhaps, whil
others are matte-finished floor tiles in muted colors. All are usefu
and should be washed and sorted according to type, size, and color

*Glass* in its many forms provides a rich source for mosaic material
Bottle glass, when fired in a kiln, loses its sharp edges and produces
great variety of colors and textures in frosted and clear nuggets
Scrap stained glass, in jewel-toned colors, may be obtained in sheets
nuggets, chunks, and cubes from manufacturers and stained glas
studios. Inquire at plate glass shops or mirror shops for remnants o
broken mirrors which may be cut into tiles or other shapes with
glass cutter. Other colored and clear glass may be obtained from
companies that manufacture glass for decorative and household uses
Other scrap or "found" glass may include marbles, costume "jewels,"
optical lenses, prisms from light fixtures, buttons, and broker
stemware.

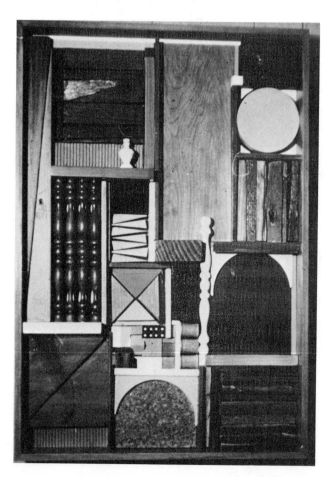

**Figure 5.3** *Amicus Curiae* Chris
Lemon. An imaginative use of found
materials including spindles, finials,
spools, domino, cork, and corrugated
paper. Stained with accents of white,
yellow, and orange. Photo courtesy the
artist.

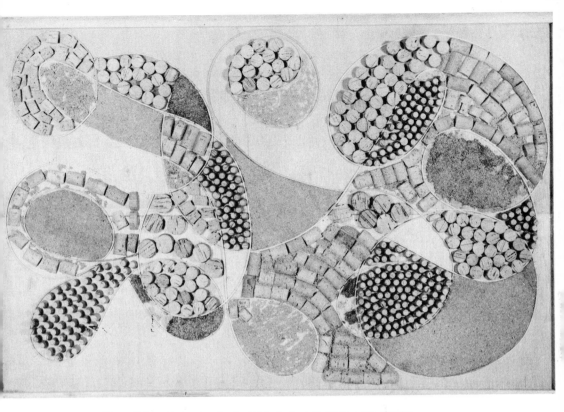

**Figure 5.4** *Abstract*  Junior High student, Baltimore City Public Schools. Corks, wood shavings, and reed. Corks of different sizes are set on end, sliced and split. White glue was used to adhere the corks and shavings, the reed is attached with staples. The base is the discarded top of an old wood blueprint cabinet.

*Wood* scraps can usually be obtained for the asking from local woodworking shops. Strips and dowels may be sawed into workable shapes such as cubes, discs, or random lengths that may be used alone or in combination with other mosaic materials. Other sources of scrap include cabinetmakers' shops, lumberyards, and home or school workshops. Other interesting wood shapes are playing pieces from games, discarded kitchen tools, spools, piano keys, and wooden beads. A trip to the beach can provide a basketful of silvertoned weathered wood: look for small, smooth slivers, old fishing floats, weathered planks, and wood blocks.

*Beach pebbles* present such an array of shapes, sizes, and colors that, collected in sufficient quantities, they can provide all the variety needed for an entire mosaic project. Collections should **115** include not only the unusual, oddly marked pebbles but good

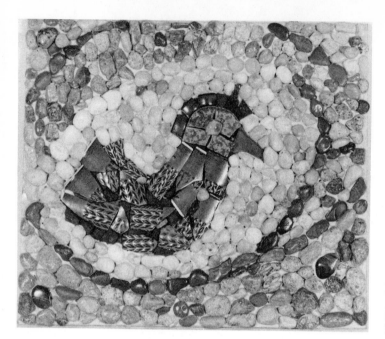

**Figure 5.5** *Bird* Found materials adhered to hardboard with acrylic modeling paste. The body of the bird is made of fragments of a broken cup; the head is scrap floor tile; the eye and beak are scrap glass. The background is made of beach pebbles. After they were set, the pebbles were rubbed with floor wax to heighten their colors. Predominant colors are reddish browns, beige, and white; the eye is bright amber. 12″ x 14″.

quantities of the more common types as well in light, medium, and dark tones. Other stones that may be used are slate, stones from garden and florists' supply shops, aquarium stones, and bird gravel. Monument designers may supply scrap marble in white, gray, rose, and green tones.

*Seeds and varieties of dried beans* are popular, especially with younger people who may have difficulty in cutting other mosaic materials. When these materials are used, results are generally more pleasing when the seeds or beans are left in their natural state; dyes and paints detract from their subtle and muted colors. Avoid food materials that are easily crushed or broken or that lack at least some degree of permanency. Collect those that have strong contrasts in light and dark tones and interesting textures.

*Metal* forms may include bolts, nuts, screws, a variety of nails, tacks, and metal fasteners. Repair shops may yield watch and clock parts, parts from musical instruments, and parts from small appliances.

A complete listing of scrap materials for mosaics would be endless. When you have experimented with a variety of found "tesserae," the possibilities seem unlimited, and collecting mosaic materials can become a fascinating activity.

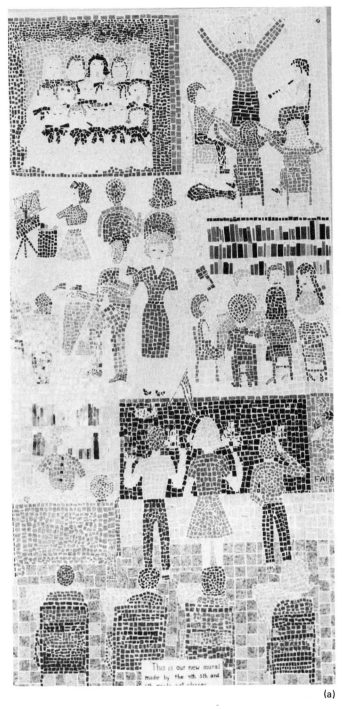

(a)

**Figure 5.6** *Floor Tile Mosaics* Students, Oak Knoll Elementary School, Fort Worth, Texas. School activities provided the source of design for these lively interpretations in scrap vinyl floor tile mounted on plywood with white glue and grouted. In (a) indoor activities are shown.

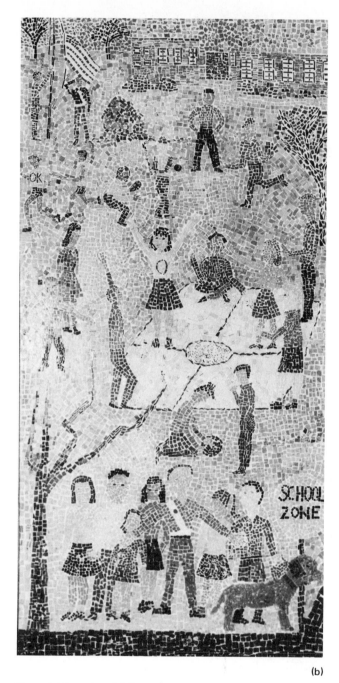

**Figure 5.6** (*cont.*)    (b) Shows outdoor activities. Photos courtesy
Jeannine Hopkins.

**Figure 5.7** *Untitled* by Ellwood Miller. A variety of textures and patterns are created in this panel which included pebbles, sawed metal tubing, and metal rods. The rods project approximately ½-inch. The entire surface was sprayed with white paint.

## PREPARATION OF MATERIALS

The preparation of mosaic tiles is comparatively simple. If packaged in bags, tile may be cut, or nipped, to the desired shape and adhered. Tiles mounted on paper sheets should be soaked briefly in warm water to which a bit of detergent has been added to remove the glue. When the tiles are loosened, remove them from the water and place them on old newspapers to dry, after which they are ready for sorting and cutting.

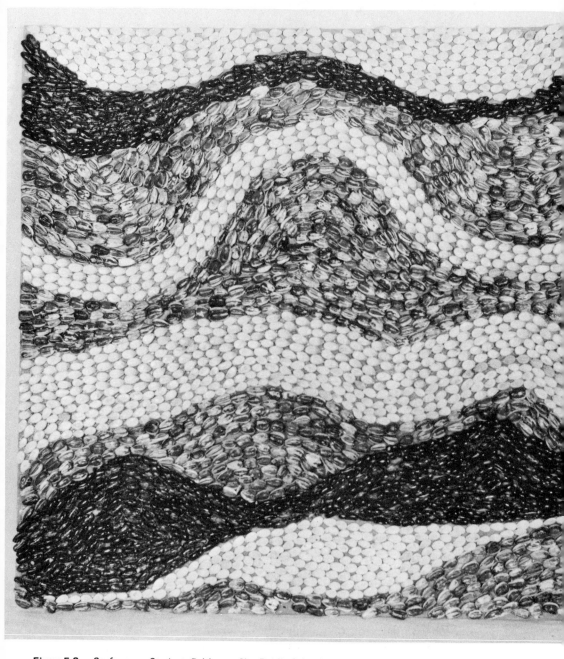

**Figure 5.8** *Seaforms*    Student, Baltimore City Public Schools.
Seeds and beans adhered to corrugated board with white resin glue.
Note strong contrasts of values and the textural interest created by
the use of variegated seeds.

The preparation of scrap or found materials is, of course, determined by the nature and condition of the material itself. *The material must be clean and free of any soil or debris that would prevent its being properly adhered to the base or support.* In addition to cleaning, some materials may require a slight reshaping or finishing that will make them more attractive in the finished design.

Natural materials such as beach stones and wood should be washed to remove sand, seaweed, and unwanted stains. Use household bleach to brighten and clean white pebbles and shells; use a stiff brush to clean wood fragments.

**Figure 5.9** *Bouquet* Elementary student, Baltimore County Schools. Melted scrap glass adhered with white glue on a wood base. The base was painted white for maximum reflection of light.

*Metal surfaces* should be polished with emery cloth if a bright surface is desired or cleaned with metal polish. Soak oily or greasy metal shapes in solvent and wipe dry to insure proper adhesion. Remove rust spots with emery cloth or liquid rust remover, available at hardware stores.

Use tile nippers to cut away unattractive edges of scraps of broken ceramicware or glass. Edges of marble scraps and slate can be shaped, somewhat, with a hammer.

*Wood* shapes may be stained before being adhered to a base but avoid stains that are excessively waxy or oily, since these may interfere with proper adhesion.

*Glass* surfaces should be kept as clean as possible throughout the designing process. Once the glass has been washed and dried, avoid handling it. Oil from the skin will prevent sheet glass from cutting properly, since the wheel of the cutter will skip over an oily surface. Glass to be joined with epoxy cements or polyester resins must be free from oil, wax, or grease, which would prevent proper bonding. Glass to be fused or fired must be sparkling clean. When in doubt,

**Figure 5.10** *Mosaic Tabletop* Student. Photo courtesy Bonnie Malcolm. Ceramic tiles mounted on plywood and grouted. Wood strips form protective edging.

**Figure 5.11** *Rooster* Students, Los Angeles City Public Schools. Broken fired ceramic slabs adhered to plywood. Photo courtesy Bonnie Malcolm.

**Figure 5.12** *L'Escargot Amiable* Chris Lemon. 20 inches high. A three-dimensional support for glass constructed of bent and soldered galvanized strips and screen. Photo courtesy the artist.

use an alcohol solvent for the most effective cleaning of glass surfaces.

## HANGERS AND HARDWARE

If panels are not to be bolted in place, determine how they may best be mounted or suspended and provide screw eyes, wire, metal hangers, or other appropriate hardware. These should be attached before the panel is laid. If the panel is to be bolted in place, leave areas of the base free of mosaic material. These areas may be finished after the piece is installed.

## GROUP ORGANIZATION

The diversity of mosaic materials, tools, and activities can be managed easily if there is effective organization of storage, work space, and clean-up procedures. Since the group will share materials, tools, and work space, it is important that good working habits be maintained throughout the activity with each person sharing responsibilities.

*Work areas* can be arranged as classroom furniture permits. Push individual tables together if materials must be shared. If tables or desks are uneven in height, place a sheet of heavy plywood over their tops for a level work surface. Cover work surfaces with newspaper or sheets of plastic film to protect them from cuts, scratches, and the strong adhesives used with mosaics. When thoroughly dried, these adhesives are extremely difficult to remove, requiring laborious scraping or the use of special solvents.

*Work in progress* can present a storage problem, especially in a small room. In some instances, panels can be stacked, one on top of the other, if damage to the surfaces can be ruled out. If surfaces are uneven, place small cardboard boxes between the panels before stacking. Before storing panels upright, on their edges, be sure that the adhesive has dried sufficiently or else the tiles or other mosaic materials will slide down the surface of the panel. Wood strips of uniform height may be placed between panels in a stacked arrangement on a countertop. This arrangement permits the storage of a good number of panels in a relatively small area. Irregularly shaped mosaic designs such as sculpture pieces, planters, or trays may be

stored on shelves improvised from cardboard boxes and boards.

(a)

(b)

(c)

**Figure 5.13** *Ceramic Tile Mural* Courtyard, West Genesee Senior High School, Camillus, N.Y. Sylvia Vander Sluis, student designer and coordinator. Photographs courtesy Dorothy Allen, Art Coordinator. (a) The design was drawn on a base of ¾" marine plywood, painted with latex paint. Chicken wire is stapled to the base to reinforce the cement. (b) Tiles made by art students and art club members are used throughout the design. Here, a student uses a hammer to shape tiles to fit small areas. Rubber gloves are worn to protect the hands from cuts. (c) Because of the relatively fast setting time of the cement, only a small area can be completed at a time.

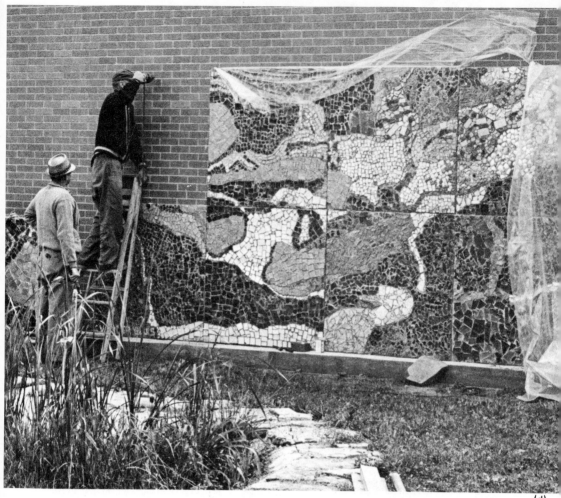

**Figure 5.13** (*cont.*)    (d) The completed mural, 18′ x 10′ in fifteen
sections, is installed by the school district maintenance crew.

*Storage of Materials and Tools*

Provide sturdy appropriate containers for mosaic materials. Tile, in
quantity, can be quite heavy and sturdy containers are a must. Sheets
of tile may be stored on open shelves, if they are available, or in
corrugated or wood boxes. When tile has been sorted and cut, cigar
boxes are ideal storage containers since they are sturdy and stack
compactly on any flat surface. Label the ends for identification.
These little boxes, easily obtainable, are also ideal for storing sorted
pebbles, small pieces of stained glass, metal parts, and collections of
all sorts of found materials. Lighter-weight materials may be stored

in shoe boxes or other sturdy cardboard containers. Large, gallon-size plastic jars are practical for storage of small items and are usually available from institutional kitchens.

Larger, bulkier items such as driftwood may be stored in corrugated cartons or in wood fruit "lugs" used for packing grapes, available at supermarkets and grocery stores. An added advantage is that these containers are stackable.

Since glass presents some hazards in storage and handling, consider using metal record album racks for smaller pieces of sheet glass or an old bookcase turned on end. If glass must be stored flat, in a box, use excelsior or shredded newspaper between sheets of glass to avoid cuts and breakage. Provide gloves, near the storage area, to be used in handling glass. *Goggles to protect the eyes from stray bits of glass should be worn by anyone cutting glass.*

Glass jars may be used for storing beans and seeds and plastic tiles since these materials are comparatively lightweight. Plastic or metal boxes may be safer for very young mosaicists where breakage is more apt to occur.

**Figure 5.14** *Mosaic Sculpture* Gail Van Vliet, KOFA High School, Yuma, Arizona. Ceramic tile. A three-dimensional form requires a sturdy armature to support the combined weights of tile and plaster or cement. (a) Setting tile on the figure.

(a)

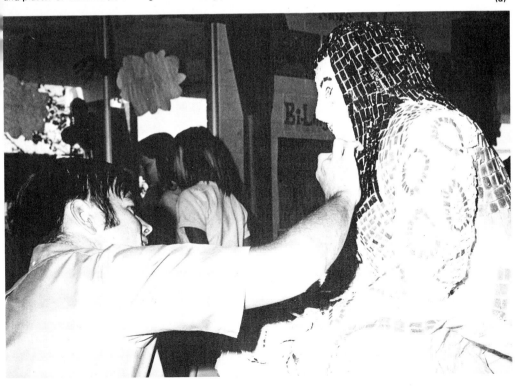

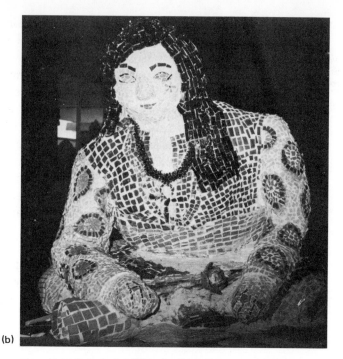

(b)

**Figure 5.14** (*cont.*)　(b) The completed figure. Note variety of
pattern and the incorporation of the symbols of contemporary
youth—long hair, the peace symbol, and the flower held in the
hand. Photos courtesy Marion Elliott.

To transfer mosaic materials from general storage to work areas,
place them in aluminum TV dinner trays or muffin tins, depending
on the number of people to be supplied. Shallow containers are best,
providing quick color identification and easy access by a number of
students.

In planning ahead, it is wise to anticipate needs and to have on
hand a good quantity of easily stored boxes or other containers and a
wealth of clean-up aids such as rags, sponges, and newspapers.

Tools may be shared, since it is unlikely that the average art room
can provide tile nippers or cutters for each person. To eliminate some
problems, tiles may be cut in advance of need and stored in boxes.
Two or three group members may be assigned to breaking scrap
tile—between newspaper padding or old burlap bags—and placing the
random shapes in boxes for distribution whenever needed. A central
"cutting area" may be set up for cutting glass or further shaping of
scrap tile. Available tools can be organized in box kits and placed
with groups of people who may share them during the work period.
These kits need not be elaborate: nippers, small spatulas, or tongue

depressors for spreading mastic or cement, a small hammer—not much else is really essential. Tweezers may be helpful in positioning very small fragments, but even these can be manipulated with a small sliver of wood or stick. A screwdriver may be helpful in prying up dried tile or a stubborn bit of cement or mastic.

**Figure 5.15** *Owl* Student, Baltimore City Public Schools, Beans seeds, and split peas; white glue on bookbinders' board. Materials are left in their natural state. Note simplification of form.

*Glues and cements*, relatively expensive items, should be used carefully, especially those with a short "open time." Drying or setting-up rates vary and you should learn to watch for the formation of a "skin" on top of glues and cements; this indicates that the setting process has begun and that the material will not remain workable for very much longer. If not used from the original containers, adhesives should be distributed conservatively in containers that can be closed. Adhesives should be spread over a relatively small area at a time, covering only the area that can be set with tile before the adhesive forms a skin on its surface.

**Figure 5.16** *Abstract* Student, Baltimore City Public Schools. Beans, white glue on corrugated board. Note the movement achieved by placement of beans to follow contours of the curving shapes.

At the end of the work period, tools should be cleaned thoroughly and replaced in kits or other storage area. Bits of usable scrap should be salvaged, sorted according to color, and saved for future work sessions. Work surfaces should be brushed free of debris. *Do not brush work surfaces with your hands; bits of tile and glass cause painful cuts.* Newspapers or other covers for the work surfaces may be discarded or folded and put away for re-use. Clean the rims of spouts of adhesive and solvent containers and seal securely.

**Figure 5.17** *Lunar Landscape* Elementary student, Baltimore
County Schools. Although seeds and beans are almost uniform in
size, a subtle variety is achieved by varying colors in the middle
ground. White glue on pressed board.

## Display of Group Work

As mosaic projects are completed, plan a display or exhibit that
can be shared with the group and the community. If available display
cases are inadequate, investigate the possibilities of arranging a dis-
play in a foyer, a wide corridor, or other area where display panels or
tables may be safely set up. An outdoor show, in a school courtyard,
adds interest and excitement for beginners eager to share their com-
pleted work with friends and families.

A local store or crafts shop may lend its display windows for
several days or a week. Cards lettered with the beginner's name,
school or group, and the materials used in the design provide
information and added interest.

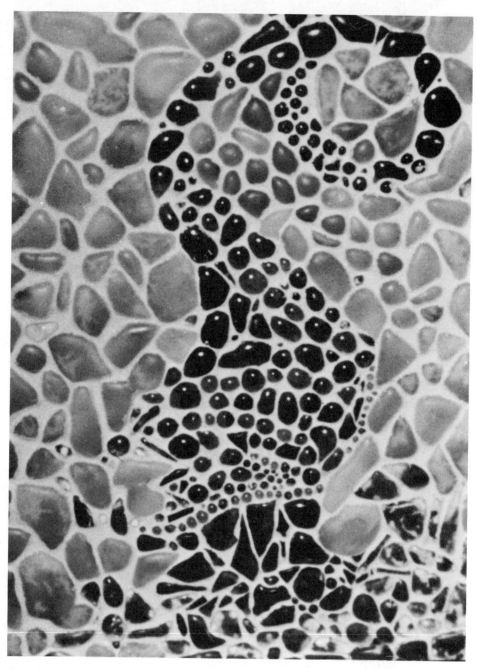

**Figure 5.18** *Sea Form* Student, Baltimore City Public Schools.
Kiln-fired scrap glass. Adhered to Masonite base with white glue and
grouted.

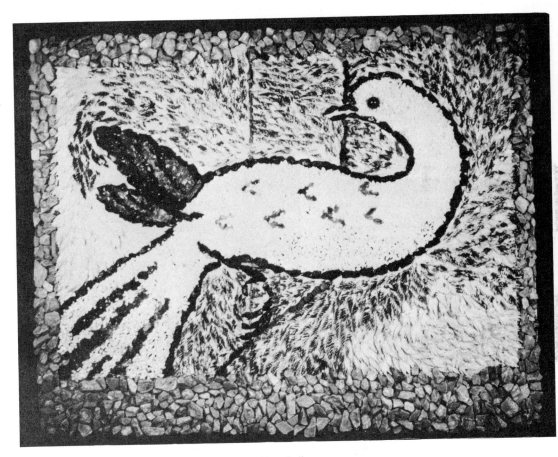

**Figure 5.19** *Bird* Student. Materials include pebbles, shells, glass, and found materials. Paint was brushed over parts of the background to provide stronger contrasts in values. Photo courtesy Chester Alkema.

**Figure 5.20** *Button Mosaic* One of ten button-covered glass doorpanels. Dr. and Mrs. George Wells, Baltimore. Buttons, largely mother-of-pearl and neutral colors, were adhered with quick-drying clear cement. Work was started at the bottom of the panel to prevent the buttons sliding down the glass before the glue dried. The translucent buttons assure privacy without completely blocking the passage of light. Photo courtesy Betty Wells.

**Figure 5.21** *Paperboard Mosaic* Scraps of board were painted with acrylic colors, then glazed with acrylic gel medium. Cut into tile shapes, the glossy board resembles glass. Photo courtesy Binney and Smith Studio, New York.

134

**Figure 5.22** (Detail) *Zodiac* Polymosaic mural. Students.
Dumont, N.J. High School. Photo courtesy Poly-Dec Co., Bayonne,
N.J.

**Figure 5.23** *Memorial Window* Presbyterian Church, Franklin Lakes, N.J. 6' h. Mariette Bevington. One inch thick stained glass cast in epoxy. Note how edges of glass have been faceted for maximum refraction of light. Photo courtesy the artist.

**Figure 5.24** *Mosaic Mural* Joe Testa-Secca. South facade, Administration Building, University of South Florida, Tampa. Photo courtesy University Information Services. Note the balanced organization of light and dark areas and the contrasting vertical and horizontal movements in nonobjective design of glass and ceramic.

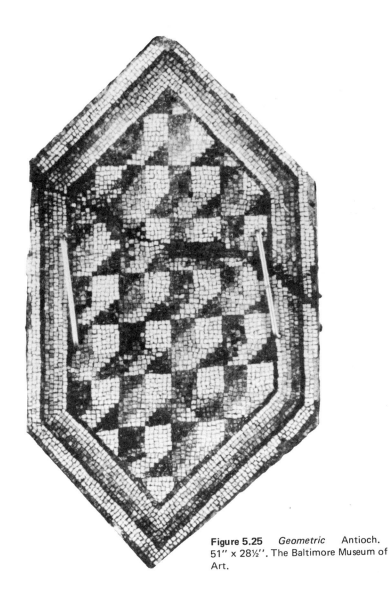

**Figure 5.25**  *Geometric*  Antioch.
51" x 28½". The Baltimore Museum of
Art.

# Glossary

*Acetate.*    Sheet plastic that can be used as a foundation or separator between resins and a working surface. It can be peeled away from hardened plastic surfaces.

*Aggregate.*    Materials such as Vermiculite, Perlite, Zonolite, which can be added to cements and mortars.

*Armature.*    A supporting structure over which other materials are applied; may be wood, wire, papier-mâché or combination of these.

*Catalyst.*    As used here, the chemical agent added to a resin to initiate hardening or polymerization.

*Cullet.*    Crushed, nuggetlike glass, available in mixed or single colors at glass factories.

*Dalles.*    Thick slabs of glass, commonly used in casting techniques.

*Direct Method.*    Method of making mosaics in which the tiles or tesserae are set individually and directly into the setting bed.

*Epoxy.* An extremely strong thermosetting resin used in adhering and embedding mosaic materials.

*Grout.* The material used to fill the crevices between mosaic tesserae, generally a mixture of cement and sand or marble dust.

*Hardware Cloth.* Heavy metal mesh used as a reinforcement for cements and mortars.

*Indirect Method.* Method of making mosaics in which tesserae are set *in reverse* on paper, then transferred to the permanent setting bed.

*Lamination.* Bonding layers of materials into a solid unit. In mosaics, lamination involves the use of plastic resins and glass or plastic sheets.

*Magnesite.* Oxychloride cement, used as a setting bed for mosaics. In the trade, "oxy-mag" cement or Sorrell cement.

*Magnesium Chloride.* Crystals that are dissolved in water to form a solution that is used to wet and mix magnesite cement. The strength or concentration of the solution determines the setting time of the cement.

*Marme.* Small cubes of marble, one of the oldest mosaic materials.

*Mastic.* Thick puttylike adhesive used for setting mosaic materials.

*Mineral Pigments.* Concentrated dry colors used to color cement, clay, and epoxy resin.

*Mosaic.* An arrangement of separate fragments or elements in a unified whole.

*Mylar.* A plastic sheet used as a separator between synthetic resins and the working surface. It can be pulled away from hardened plastic surfaces.

*Plasticene.* Nonhardening modeling clay.

*Polyester Resins.* Popularly, "plastic" resin used with a catalyst, in laminating and casting techniques.

*Smalti.* Byzantine tiles that are hand-cut from slabs of opaque glass. Surfaces are irregular, producing a highly reflective and varied mosaic surface.

*Tesserae.* In popular use, the fragments used in creating a mosaic design.

# Suppliers

### MAGNESITE CEMENT

Kaiser Aluminum Chemical Sales, Oakland, Calif.

J. E. Steigerwald Co., Baltimore, Md.

### CUTTERS, NIPPERS

*Hardware stores; craft suppliers. Professional-grade tools may be obtained from the following:*

Beno J. Gundlach Co., Belleville, Ill.

The Starrett Co., Athol, Mass.

### PEBBLES, GRADED STONE

*Garden supply shops; florists' shops, or order:*

Askia, Box 2567, Eugene, Oregon (Also supplies shells, lava, etc.)

Miya Co., 373 Park Ave., S., New York, N.Y.

### PLASTIC TILES
CCM Arts & Crafts, Inc., College Park, Md.

Poly-Dec Co., Bayonne, N.J.

### GLASS
Blenko Glass Co., Milton, W. Va.

Kay Kinney Glass, Laguna Beach, Calif.

Whittemore-Durgin, Hanover, Mass.

Willett Glass Studios, Philadelphia, Pa.

### SYNTHETIC RESINS
Benesco, St. Louis, Mo.

The Castolite Co., Woodstock, Ill.

H & M Plastics, Philadelphia, Pa.

The Sema Co., Pikesville, Md.

Shell Chemical Co., Plastics and Resins Div., New York, N.Y.

Thermo-set Plastics, Indianapolis, Ind.

### MOSAIC MATERIALS
CCM Arts & Crafts, Inc., College Park, Md.

Mideast Ceramics, Inc., Timonium, Md. (Ceramic and smalti; tools)

Mosaic Workshop, Los Angeles, Calif.

Ravenna Mosaic Co., St. Louis, Mo.

### ADHESIVES
*For special adhesives; to solve adhesive problems:*

Adhesive Products Corp., 1660 Boone Ave., Bronx, N.Y.

### MODELING PASTE
*Suppliers of acrylic paint media:*

Bocour Artists, Inc., Garnerville, N.Y.

M. Grumbacher, Inc., New York, N.Y.

Hunt Mfg. Co., Philadelphia, Pa.

Permanent Pigments, Cincinnati, Ohio

## METAL PASTES

Economy Handicrafts, Flushing, N.Y.

The Sculp-Metal Co., Pittsburgh, Pa.